Wildlife Painting

Wildlife Painting

Joy Parsons

B. T. Batsford Ltd, London

*To Mickey, whose help and close contact
with nature were invaluable.*

© Joy Parsons 1984
First published 1984

ISBN 0 7134 4106 2 (cased)

Phototypeset by Keyspools Ltd, Golborne, Warrington
and printed and bound in Great Britain by
Anchor Brendon Ltd, Tiptree, Essex
for the publishers
B. T. Batsford Ltd
4 Fitzhardinge Street
London W1H 0AH

Contents

Introduction

People's interests vary enormously and everybody is searching for something different: the fishermen make for the streams and rivers with an eye to the catch; the entomologist looks for insects; the huntsman and the 'good shot' are out to kill; the botanist examines the plant life; the tripper's only thought is a suitable site for his picnic – but the artist, now, what of him? The difference is that he sets out (we hope) with an open mind, and what will *he* find? He just never knows, you see, beyond the fact that he is surely interested in things like atmosphere, pattern, shapes, colours, light and shade and textures. Of course, what he observes and what he makes of what he sees will vary according to his perception, desire and ability. People's choice of subject matter differs greatly and usually changes over a period of time.

Looking back over the many years I have been painting flowers and landscapes, I realise that my own first wildlife aspiration and inspiration was no more than a spider on his web. However, a journey across the world, as they say, has to commence with one step. That spider has no idea how he was to lead me on to so many hours of happiness (and frustration).

I soon realised that, for me, it was quite the most challenging type of work. After all, if a human model moves, you can mention it, but you can hardly ask a bank vole or a frog to sit still. Naturally, it is important that you are fond of animals. Matisse, for example, surrounded in his studio by his flowers and fruit, used to talk of the need to achieve that close rapport with them in order to produce a successful painting.

Whilst at times we may all take pleasure and initiative in moving the position of a tree, re-arranging the composition of a landscape, adding or subtracting a bloom here and there in a flower group, it just isn't done to leave off the leg of a frog or the eye or wing of a bird. Endless patience and keen observation are the most necessary ingredients for success. Delacroix once spoke of the 'intoxication' of work. How well I know what he meant; even if the sobering up process when assessing the final result has to be endured, the experience has always been worthwhile.

It is, I think, very important that you should not attempt to draw any creature to whom you have no access, and that you only use photographs or similar *after* you have made your own drawing to the very best of your ability, simply as a reference and to check up on one's mistakes. There is scant merit or satisfaction in attempting to make an exact copy of a photograph or painting where the camera or another painter has done most of the hard work, i.e., deciding on the pose of the bird or creature, where it should be placed within the picture plane, what colours to use, etc. These are

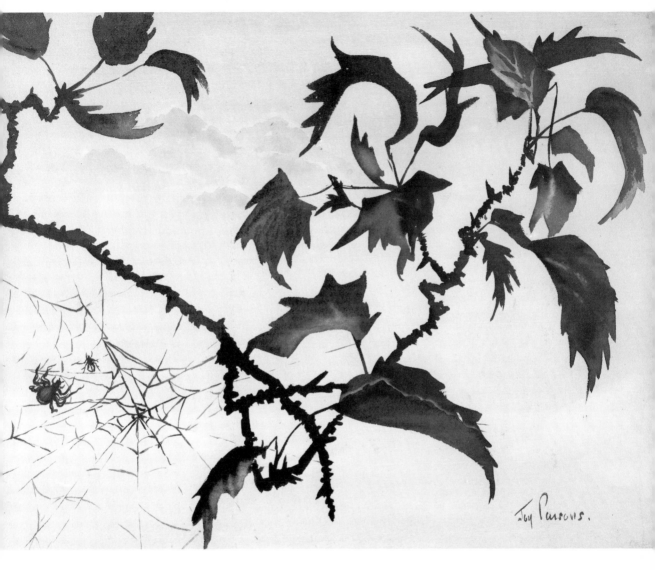

the decisions by which we learn. Stuffed birds can occasionally be useful as a reference, perhaps to check on plumage patterns but they can also be misleading as their feathers get ruffled and incorrectly placed with age and most certainly, unless you are very lucky, they will be faded. So be wary!

You will find your subject matter in bird gardens, zoos, aquariums and the countryside but, best of all, the wildlife that probably abounds within your own garden once you become aware of it.

An important part of your equipment should be a pair of binoculars and a magnifying glass in case you are examining a dead 'something'. It is surprising what turns up once you have made a start and people bring in injured 'models' which can be given first aid and at the same time provide much information for your sketchbook (this should be kept handy at all

1 The spider which started it all! Painted in monochrome, using Sepia. I remember sitting alongside a rubbish heap to do this chap on the branch of an overhanging apple tree. Little did he know what a caper he was starting.

times, ready for the unexpected). Do make quite sure, however, that no creature suffers to suit your painting desires! Practically everything responds to common sense and kindness. The biggest battle when you are beginning is 'learning to look' – so often we look and do not register what we see and then, having seen, the difficulty is to remember!

It may be that you do not wish for any type of background or bric-a-brac for your models but for those who do, I am including a section on painting flowers and berries. So often the impact of a picture is made by placing the little creatures in an appropriate setting. My little voles, for instance (*Fig. 122*), could be up the syringa tree or in the heart of the honeysuckle bush in the garden just as easily as on the ground.

So, whether you are already an experienced painter or a beginner, you will find, I hope, many hours of enjoyment and accomplishment from a new source of interest, and that the examples and descriptions of my own struggles, adventures and results may start you off!

Materials & Techniques

Materials

Life for the artist was so much simpler in the days when there was just a small choice of media. Now, we all know the fascination of the colourful arrays in the art shops, inviting us to spend our money and try yet something else!

My studio

Perhaps I should start by describing the contents of my own studio – not a large nor a very tidy room, I fear. The one thing, however, that must be kept well-organised is my sketching bag – always 'at the ready' as one never knows when the urge will take one or when the call will come. In this bag I keep my folding easel – an old photographic tripod on to which screws a special board of plywood adapted with a metal plate and capable of tipping to any angle. This board happens to be between sizes (i.e. 2 in. short of a half imperial) and fits into the bottom of my present suitcase. So, with the addition of my sketching (duffle) bag, I can travel reasonably unencumbered, which gets more and more important as the years go by!

In this bag I also take a 'stick' easel which is very quick and handy; a folding stool; a plastic water bottle; a small tin of favourite bits of pastel; a small tin of oil pastels, complete with scrap of cotton wool and a little turps in a pill bottle; a small plastic case containing knife, matches, masking fluid, putty rubber, Indian ink and mapping pen; a brush case containing my pet brushes; a rubber ball with the top cut off which is used as a water container and hung by a bit of string attached to each side and fastened to my board with a bull-dog clip; an old plastic mac or a large plastic bag into which I can put my feet and legs when sketching in the cold or otherwise, to keep me clean as well as warm. That, I think, is just about it, apart from a paint rag and the one thing I cannot do without – my tins of watercolours. These are ancient cigarette tins which have done noble service for so long I see no reason to change them now. I always prefer tubes, and keep one tin for the reds, yellows and pinks and the other for the blues, greens, umbers and dark colours such as Paynes Grey, and so on.

In my studio there is a table easel perched on top of three large plan-press type of drawers on four legs. These drawers give me much storage space. There is an old dresser, the top shelves of which are covered with my collection of shells, then come all the oil pastel boxes, a box of clips, and a fixed pencil sharpener. The shelves below are filled with more sketches and tracings. The bottom shelf contains at the moment a bag of the silver sand from Loch Morar in Scotland, bones, feathers and oddments. There is another large plan-press containing paper and more old paintings, a rack

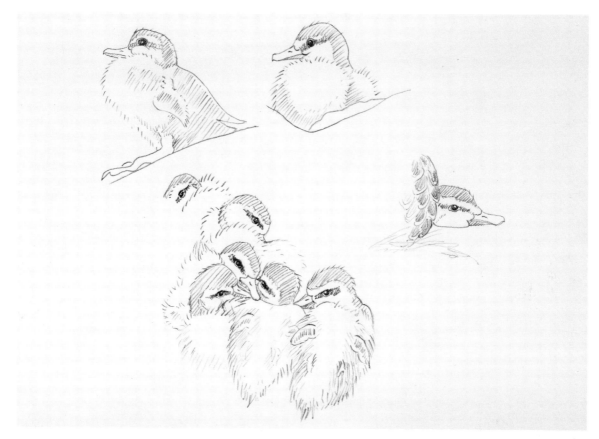

overhead for storing canvas, mounting boards, etc. and, on the other side, a working bench with shelves below and a fluorescent light overhead. I use this for cutting, trimming and 'sorting'. Under my working table is a variety of boards, plywood, hardboard and one or two old picture backs which are easy to get pins into. Overhead is a suspended light and behind a couple of bookshelves. The walls are covered with perforated hardboard, so there are always all sorts of things hung or suspended and various dead or drying flowers and seed heads around. I have a high stool, and sometimes stand and sometimes sit to work. My brushes lie to the right of my drawing board and extra ones alongside in jars. Two jars of water close by and another pot of pens and pencils.

It all sounds fairly organised when I write it down but somehow when you get there it doesn't strike you that way. For those who may not be lucky enough to have a complete room to give up to paint in, it is terribly important that you at least have your own 'corner' where you can leave everything in the middle of a job, if necessary, and do not have to put it all away or tidy up. Everybody, I'm sure, can manage this with a little thought and arrangement. So often it is the effort of getting everything out and getting started that impedes progress; if you can just rush in and pick up a brush or pencil when a thought strikes you, it helps so much.

2 Here I have used a 3B pencil to give you some idea of my ducklings.

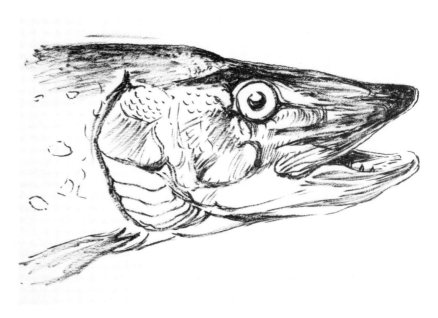

3 Pike's head. I started with the eye, as usual, and used a brush pen (they come in various colours).

4 (*opposite*) This owl was done from a pen drawing, using a brush and Indian Ink.

Paper

The paper on which you make your mark is the first consideration. My best friend is Bockingford paper (140 lb weight – I rarely use the heavier 200 lb type). It takes a wash beautifully, the manufacturers tell you that you can use either side equally well, and it does not need stretching. I will often attach it to my board with strips of masking tape and then, when the work is finished, I can peel off the tape carefully leaving a clean, tidy, white edge, like a little mount. Bockingford, however, will not really tolerate the use of a rubber so only use it for direct brushwork as far as possible. Paper surfaces come as rough, not and hot pressed, the latter being very smooth and more suitable for pen or pencil work or fine brushwork.

Another favourite is the French Arches paper (I use the rough usually). This can be used unstretched if (which is usual with this paper in my case) some texturing is needed. On the other hand, of course, there is nothing so inviting as a well stretched piece of paper, calling you to make your mark on it. For those who do not know how this stretching is operated, the necessary sheet of paper is completely submerged in water in a bath or basin and left for several minutes until really soaked. It is then taken out, held up for a minute or two in order to drip off a little, and then laid down on to the waiting drawing board without twisting or stretching if possible. Lengths of brown gumstrip which have already been cut (a little longer than the length of the paper) are then also wetted and laid down catching half the paper edge, thereby leaving the other half to adhere to the board. Press the gumstrip down very firmly, starting in the *middle* of the strip, and press out both ways. This will eliminate the risk of stretching the paper in one direction only, in which case it might dry with a 'pull' in it. Leave it to dry flat in a moderate atmosphere (not too hot or it will stretch itself too taut and even rip or pull off the board, such is the pressure).

12

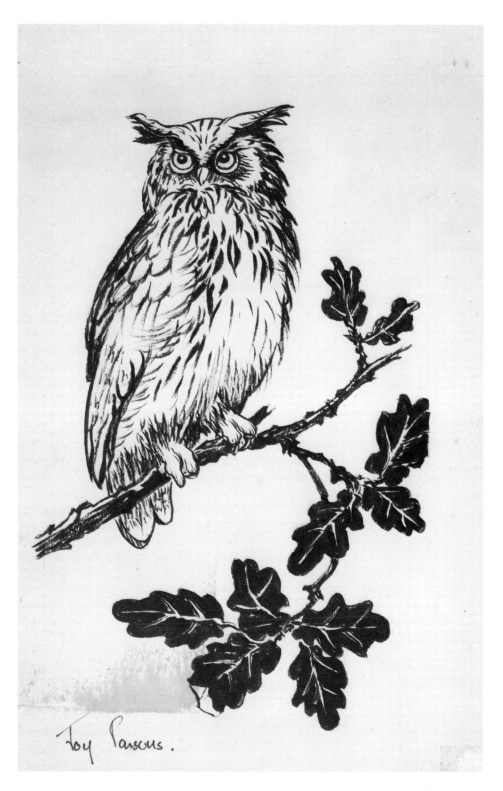

Foy Parsons.

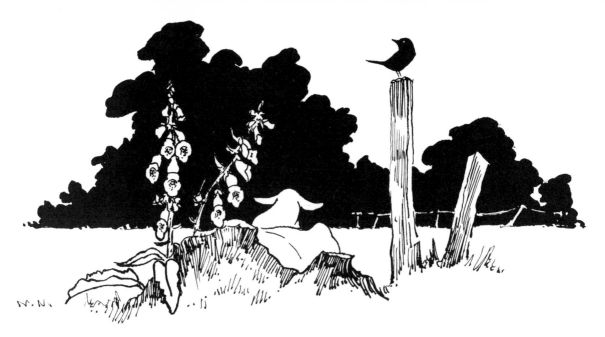

5 Never minimise the impact of pure black and white. This little scene caught my eye one day and whilst the goat is not exactly 'wildlife', the blackbird and foxgloves are! Some of this was put in direct with a fine brush and Indian Ink and the remainder with a pen, having first done drawings, of course.

If working with gouache, the comparatively cheap Art Cover paper is one of my regulars, provided it is stretched first. Most of the colours in which it is supplied are too gaudy, but the grey and the brown are most useful. Pastel papers such as Ingres and Canson can also be used for gouache, but must be stretched first or they will cockle. It pays to try any coloured paper that comes your way and, incidentally, I find the slips of card that come with a new pair of tights are quite useful for note-making or little sketches. One side is white and the other side grey! If using one of the very heavy-weight papers, they do not need stretching, but must be thoroughly but gently *sponged* before use.

For those unfamiliar with the term, gouache is watercolour to which white has been added, thus making it opaque as opposed to pure watercolour. You can either use the special Designers' colours which are good and strong or your straight watercolours and add Poster, Process or even Chinese white if you haven't got the Designer's white. It is advisable, however, to use a separate palette and brushes as good watercolour brushes can easily get spoilt by the white paint. Gouache is a most effective medium but, as with watercolour, it is better to avoid hanging a painting in very strong light as it is possible that it will fade a little.

Of all the different types of paper, Bockingford 140 lb is probably the most popular. Saunders comes next (not surface being more generally used) and after that Arches. Greens 300 lb weight is now in the region of £5 per sheet which makes it rather expensive for regular use.

Brushes

If you can afford sable, there is no question that they are the best. If you cannot, there is now a range on the market that are 60 per cent sable and 40 per cent nylon and these are a good substitute at very much less cost. I also have two 'flats' for broader work, such as landscape, foliage, flowers, skies, etc. I have a 1 in. and a ½ in. ox hair which are in constant use. I then have a variety of smaller sables. A few *very* tiny ones that I would not dream of

using for landscape but are very necessary for the eye of a young bird or a bank vole or the centre of a close-up flower or a twiglet. Occasionally I will use a Chinese brush for this kind of work. When painting birds and creatures, I nearly always start with the eye as they then become alive to me and, like the Mona Lisa, can follow me around! On the other hand, I usually do the centre of a flower last.

Pure nylon brushes I find unsatisfactory. They do not pick up a blob of colour in the same manner as sable although, in all fairness, they do have a wonderful point and, therefore, are useful for 'drawing in'. This I do for flower, landscape and some wildlife work with a No. 6 or 5 brush and blue paint when working direct.

It is most important to take good care of one's brushes, and it is surprising how many people turn up on painting parties with a collection of brushes, usually good sables, which are blunted and pointless owing to the fact they are carried around carelessly. Often they may be in a brush case but are

6 Lovely decorative shapes, so what better way of showing them up than direct with Indian Ink.

7 Flowers from Kimmeridge. This picture also appears in my little book *Days Out in Dorset* (Thornhill Press, Cheltenham). These were carefully arranged and traced from my original drawing and then outlined in places with a very fine brush, using monochrome.

attached to nothing and so bounce up and down on their would-be points! Even a piece of folded paper or card with a couple of rubber bands around it is better protection than nothing.

Pencils and pens

In the main I use a 3B, with an H or HB for tracing if necessary and, occasionally, a 5B. Pens are a problem; again, there are so many, and new types appear so frequently that it is difficult to know where to begin. The main thing to remember is to make sure whether you are using a waterproof ink or not; to do a good drawing, decide to tint it later, and then discover it was not waterproof is a sad thing. On the other hand, you may be one of the

16

people who likes to draw in a wet wash and utilise the effect of the slight 'run' of the ink.

There has fairly recently appeared the 'brush pen' and this I find particularly suitable for plumage, especially on a slightly rough paper or when the pen is drying out a little. It gives a pleasant texture and, according to the pressure used, it is also capable of varying the width of the line most effectively. It is not expensive to buy and is available in many colours, though I only use the black or brown at the moment.

On other occasions, a fine brush with a bottle of Indian Ink is a favourite, especially if one is indulging in the joy of a pure silhouette; one should never minimise the impact of this kind of work. There is a collection of quite cheap pens in my studio; to mention a few: Nikko Finepoint runs well, a Ball Pentel (not waterproof), a Rushon, a Schwan Stabilo, an Inscribe Fineline and, of course, the old-fashioned penholder and nib which scratches along but over which one has infinite control. There are many of the felt marker types on the market as well, so take your pick! I also have a more recent sketching pen, which I do not like and which was expensive by comparison, and a little mapping pen which I used when I was collecting all the information for the life cycle of the little palmate newt (*see fig. 138*).

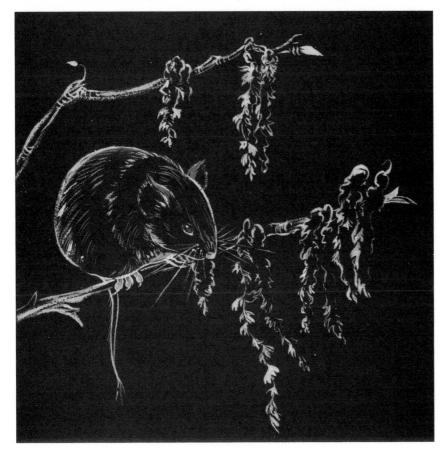

8 Don't forget white on black, will you? This vole eating catkins was put in with white gouache paint.

Drawing

The importance of drawing is obvious; it is not much use trying to paint a subject if we cannot register the shapes by *drawing*, whether with a brush or a pencil. The Shorter Oxford English Dictionary describes drawing as:

The formation of a line by drawing some tracing instrument from point to point on a surface; representation by lines; delineation, as distinct from painting; the draughtsman's art, the arrangement of the lines which determine form. That which is drawn; a delineation by pen, pencil or crayon.

To this last I would like to add brush, because when we apply a nice, juicy wash of watercolour with no previously pencilled-in line, surely we are drawing? Therefore, try to keep the two things going separately, i.e., sometimes draw with a pen, pencil or crayon and at other times paint in straight with your brush. People are often nervous of doing the latter, but once they have taken the initial plunge, if they have had plenty of pen or pencil practice, they are soon intrigued by the idea and, of course, the results are much less laboured: whilst endeavouring to stay within a pencilled line a wash can dry out in places, leaving an edge where it is not wanted, and the result can look 'tight'.

Learning to draw

Decisions must be made regarding the type of line we want to draw. Naturally this will be greatly influenced by the type of instrument and also the type of paper used. Pencils and charcoal are inexpensive and they can be rubbed out if a mistake is made, so they are the safest if you are a complete beginner! A hard pencil gives a crisp line – cartridge paper and an HB pencil are the most popular. A soft pencil, such as a B or a 3B, is a sensitive thing, and it can get smudged and a bit 'messy' if used by a beginner. The more detail you require, the smoother the paper should be. Experiments should be made – a 3B pencil on a rough paper surface can give a very pleasant result.

How you hold the pencil is a matter of personal choice. I do a lot of my drawing with my pencil caught between the third and little finger, about three-quarters of the way down the pencil, the rest of my fingers closed over it and the leading pressure being between the first finger and thumb. I use small, stitch-like strokes in the main. A good way to practise is to take a flower spray or some leaves and try, by using a *continuous* line, to draw the subject without lifting your pen or pencil off the paper. If you possibly can, try to do at least one sketch every day; this may seem to be a chore, but it

need not be so. Delacroix, for example, called his drawing his 'daily prayer', so try to think of it in this way! Keep that sketchbook handy.

Perspective

Perspective is not often thought about in connection with flower painting, but it is there just the same. If you paint a landscape you know that the windows of a house or buildings will show the onlooker the angle at which they are standing; in the same way, the amount you can see and the direction in which the centre is pointing gives you the perspective of a flower. Whilst drawing birds, of course, the angle of the tail and eyes must be carefully watched in connection with the bird's position. How much detail? What a question! It is largely a matter of taste and whether you are 'botanically minded'. To quote Delacroix once more: 'The forms of a model, be they a tree or a man, are only a dictionary to which the artist goes in order to reinforce his fugitive impressions, or rather to find a sort of confirmation of them'.

I have had a tremendous amount of challenge and enjoyment from drawing the skulls of some of our English birds which I was lucky enough to have access to in our local museum. Totally new shapes and *so* intricate (*fig. 9*). Thin like silk some of them, and so much variation. I have tried to give you the biggest contrasts as, of course, certain groups are very similar. My husband, who was an architect, was very helpful here as he pointed out that a compass or pair of dividers would help me considerably, which they did, and everything was meticulously measured by making a series of dots with the pencil end of the compass and then swinging it around. Dividers will prick the paper and not be so easy to see. Whilst up to this stage I had worked by eye alone, from now on I shall do more measuring in this field; only possible in this way with something dead, of course!

9 This was an intriguing exercise. I took the widest variety of skull shapes from the collection to which I was lucky enough to have access in our local museum. They were a challenge and, after a struggle, my husband pointed out that I needed with a compass with which to measure them. I used an HB pencil for most of them.

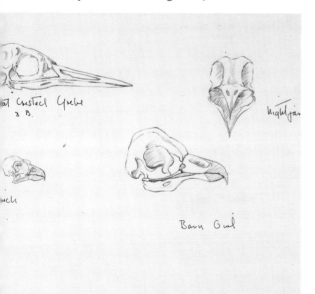

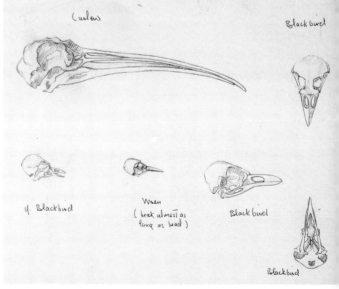

Working in Monochrome

Tone values

Whatever medium the artist decides to use, he or she should always be aware of the varying degrees of light and darkness in the subject, known as tone values. These will be found everywhere you look. From the window you see the trees or the roofs against the sky – how light is one and how dark is the other? A robin is perched on a branch of a tree or a wren in a bush – how light is the bird in comparison to the tree, is his underneath plumage as light as that on top and is it lighter or darker than the bit of leafage it come up against? That cluster of blossoms – how much lighter or darker are the ones nearer to you than those in the background? These are the kind of questions you should be asking yourself. There is no mention of colour here, it is only *tone*.

I would venture to say that if, at the end of a long session, your work does not please you, often it is the tone values that are upsetting it. Something may need strengthening or something may need lightening. It is all a question of being aware. Nine times out of ten a bird against the sky will be dark, but there will always be the tenth time when it is not, for instance in the case of a gull against a huge storm cloud. Don't forget, tone values are what will give *recession* to a piece of work.

Charcoal

Be it a pippit, passion flower or panorama you wish to portray, it is essential to know how the various media work and the type of results they will produce and so, after plenty of drawing practice, I would suggest that you experiment with charcoal. It is an extremely versatile and sensitive medium and also offers the best practice for searching out the tone values in the subject matter.

As with all the media, there are many ways of using charcoal and many strengths can be obtained. The result depends also on the type of paper you are using, and never forget that with a piece of toned paper and the addition of a bit of white chalk, some very powerful and interesting results can be achieved. For the moment, however, I suggest the use of this medium in the manner of 'dry painting'.

Dry painting

This is an exciting and lesser known method. It gives an immediate effect for a beginner and will also help to teach simplification. It can produce amazing results in the hands of a skilled artist, and I shall always remain grateful to the well-known artist and tutor who passed this method on to me in my early days.

Joy Parsons.

Putty rubber, some sticks of vine charcoal and some cartridge paper are all you will need to start with, although some rougher surfaces should be tried for varying effects later on. It is a slightly messy medium, so don't forget some tissues or rag to wipe your hands on! Take a bit of charcoal and wear it down until you have a flat side to it and then, keeping as consistent a pressure as you can manage, cover the whole sheet with a faint grey 'wash' or tone. It takes practice to apply this evenly, but it can usually be evened out by gentle rubbing in with the tip of your finger. Remember, at this stage do not use the point of the charcoal at all, keep it well on its side or you will produce a mark which you cannot get rid of.

Bearing in mind now that you are searching for tone values and not detail, half close your eyes and observe your subject. Magically, all the distracting details will disappear and you will be left only with the important main masses. Further building up can now take place on top of the grey tone you have already produced – a little darker here, a lot darker there. Then comes the real excitement; take the putty rubber and lift off your lights and, last of all, any special accents or modifications can be made.

The benefit of this method for beginners is that they can rectify mistakes and make alterations to their heart's content, provided the side of the charcoal only is used and no 'scratch' marks have been made. There can, of course, come a moment when the paper is overloaded with charcoal and won't take any more, but it is then possible to spray with fixative and work further details or additions.

10 Tone values. Using Payne's Grey here and combining flowers and landscape. This viewpoint was taken from a hotel in Swanage Bay – springtime with the daffodils. It will be observed that here is an example of tonal changes to be watched for – the daffodils are *light* against the water of the Bay and the narcissus are *dark* against the light sky. This painting has appeared in *Leisure Painter*. Watercolour again.

11 Charcoal studies. A sheet showing some of the effects obtainable with charcoal-rubbing, dragging and direct strokes – using cartridge paper.

12 A charcoal study of an old tree and a stile. A direct build-up with occasional use of putty rubber (on top of posts). Try it out, you'll either love working with it or hate it!

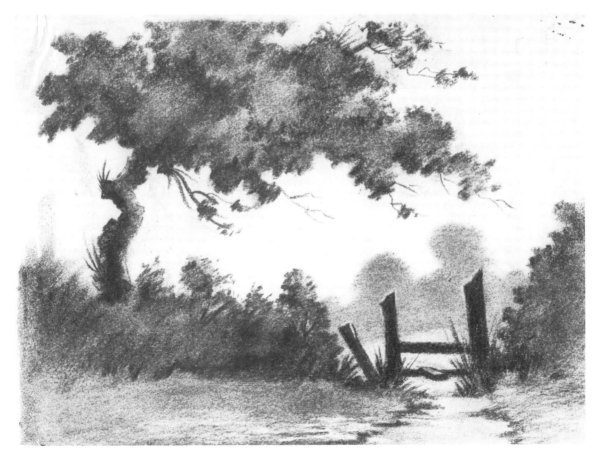

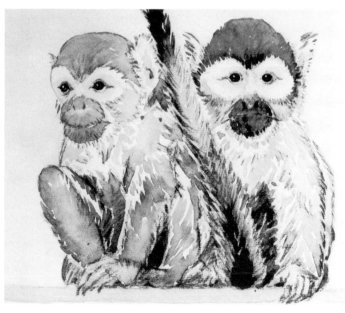

13 I found these charming little monkeys in a zoo. They were drawn in with charcoal and given a watercolour wash afterwards. Painted on honey-coloured paper.

Very subtle and pleasant results can be obtained by first applying a wash of acrylic or watercolour paint and then working on top of this with the charcoal.

Watercolour

Now, still bearing in mind the importance of tone, we come to painting; the manipulation of pigment – and that is very different. In this case it is watercolour, i.e. exactly what it says – water colour! We should now ask

ourselves what we are aiming at. I always feel that transparency is the most important thing, particularly in flower painting. It is surprising how reluctant people are to dilute the paint enough – they tend to use it much too dry and thick.

It is important to take good care of your paints. A useful tip, if you happen to have a box containing pans, is to give all the colours in your box a good 'dollop' of water so that they are softening whilst you are getting settled and making your preliminary plan and mental picture. This will save scrubbing away with your brush and wearing it out. This may, of course, not be necessary, but certainly some of the boxes which have been handed to me for a lesson, could have done with a ten-minute soak under water and may not have been used since the previous year! Keeping a clean paintbox and looking after your brushes are both very important. I frequently take my watercolour box under the tap and, though it may waste a little paint, it does ensure nice, pure colour next time round. Other times I clean round the mixing compartments with a small sponge or a tissue as soon as I have finished, ensuring that, if I want to have a go in a hurry, all will be ready.

Despite the fact that an open paintbox with its juicy colours has rather the same effect as a sweetshop window on some people, it is better to discipline oneself at the beginning and choose just *one* colour to work with. This can be any colour you like, provided it can give you sufficient strength in the darks (not, obviously, a yellow). Crimson, Ultramarine and Neutral Tint, are all used, though the more usual ones are Sepia and Burnt Sienna or Paynes Grey. My own favourite is Brown Madder. Always mix up more colour than you expect to need; vital time is often lost if you run short in the middle of a painting and hard lines can appear whilst you remix. Get used to mixing up large quantities of colour in different strengths and try them out on spare paper. A flat wash, a graded wash and a varigated wash should all be tried. Whether you are painting flower, creature or insect, try them all out in monochrome first. This may seem rather a 'chore' to start with but people usually find it is such a challenge that they are seen thoroughly enjoying themselves!

Laying a wash
You may already know how to lay a wash but in case you don't, I suggest the following: arrange your drawing board on which the paper has either been already stretched or attached with masking tape, at an angle of about 25 degrees. Mix up a large quantity of the colour you need, in this case for a flat wash, using a large brush – a flat one if you have it. Now, with as much speed as possible, take your full brush quickly right across the paper; immediately re-charge the brush and do the same thing again but *overlapping* the first stroke slightly. Continue to the bottom of the sheet in this manner and await results! For a graded wash, add one brushful of plain water to the mixture between each stroke, stir quickly and re-charge the brush. Speed is everything.

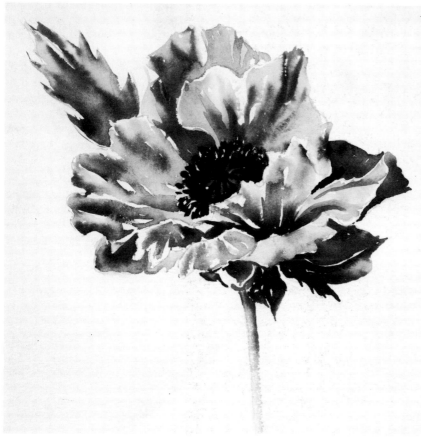

14 This painting appeared in an article I wrote for *Leisure Painter* on monochrome. Using Brown Madder I drew in very lightly with my No. 6 brush the shape of the petals as the light and shade was very tricky. The dark centre was, of course, the last touch here and one must be careful to preserve enough 'punch' for the final touches. The leaf was a direct brush drawing and these were demonstration paintings.

Working with Colour

We think of familiar objects as being a certain colour, but colour is not, in fact, inherent in these objects. The effect we see is caused by rays of light which, when they are reflected from objects and items around us, strike the receivers or filaments in the retinas of our eyes and at this point are converted into colour vibrations. Once we become aware of this fact it is easy to understand why individual colour schemes and reactions often vary so much – each pair of eyes is dependent on the number of receivers therein. Those who are lucky enough to have a large number of these will be very colour-conscious, while those who are not tend to see in a more monochrome way which can be approaching colour-blindness.

Bearing this in mind, it is not possible to say that a certain colour is 'wrong'; it is only fair to say that you perceive it in a different way. The average person, however, is aware of colour to a greater or lesser extent, but, when it comes to painting, he can be helped to find it where he had not realised it existed. It is this personal colour preference which is part of the artist's handwriting.

In connection with flower and foliage painting in particular, there is one thing which should be pointed out to the beginner, and that is the danger of preconceived ideas of colour as we know it in general. For instance, beware of the thought that all foliage is green – just plain green. If you stop and analyse carefully different leaves in a flower group (or trees in a landscape), you will find a delightful variation tending towards blues, greys and browns and now and again a glorious touch of purple or magenta in fading leaves. Always be on the lookout for anything that will give a contrast or variety. So many paintings in the amateur stages fall down on the treatment of the greens. There is a section on foliage on pp. 84–92 which I hope will be of help.

Many pigment mixtures get passed on through the years from tutor to student, and are often used unquestioningly, but try to experiment for yourself. You must realise that, although a tutor can help a great deal, the real effort has to come from you. Patience and perseverance are called for in abundance. It is no use, as so many people are tempted to do, being easily discouraged and putting all your equipment away for long periods, and expecting to make headway; you will only have to start all over again! If time is scarce it is most important to try to set aside that special corner in which to work without having to put away all the paraphernalia each time, and do try to learn to 'think in paint'; while waiting at the traffic lights or in a bus queue you can still be assessing the colours around you and mentally mixing. This will help you to make quick decisions when you actually come to paint a flower, bird or creature.

15 (*opposite, above*) For your first experiments with colour, try using just three colours. These beech and oak leaves were painted with Cadmium Red, French Ultramarine and Yellow Ochre.

16 (*opposite, below left*) Golden pheasant's feathers. This is really a 'lesson' illustration showing the usual way I use my pastel, i.e. making good use of the paper beneath, in this case Canson. I wish you could see this in colour as he really is a fabulous bird!

17 (*opposite, below right*) Doing bird portraits really can be fun. This mallard was sitting on our lawn and here a bit of rubbed pastel comes into its own.

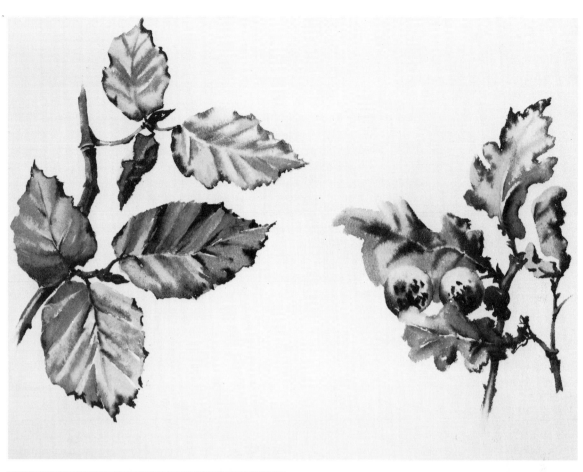

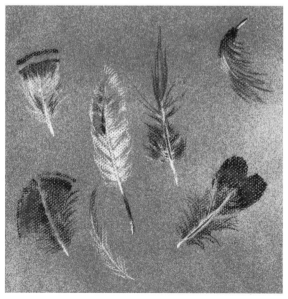

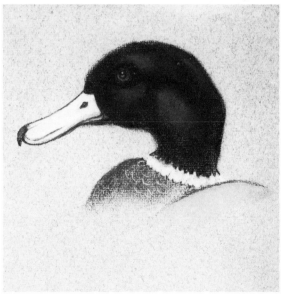

After monochrome try working with just three colours, a yellow, a blue and a red. A good 'safe' trio are Cobalt Blue, Light Red and Yellow Ochre. Much more vibrant are French Ultramarine, Cadmium Red and Cadmium Yellow (*fig. 15*).

Whilst it is undoubtedly a good thing to get used to working with a few colours in the early stages, eventually (especially with flower painting) try to break away for a change – one can get into too much of a 'rut'. A young South African painter once joined one of my sketching holiday groups. We had a typically English grey week's weather but this lad painted away undaunted. At the end of the week assessment it was obvious that he had used unremittingly the same set of colours he used at home and all his paintings portrayed bright sunshine! So, try to mix your colour according to the essence of the subject as *you* see it. People do seem to be becoming more colour-conscious, and colour therapy is now used and recognised widely in hospitals. Don't be afraid to let yourself be carried away by colours; painting flowers you have every excuse. One of the reasons painting is so therapeutic is, I think, because it is one of the few occupations which totally absorbs you; you cannot think of anything else at the same time and thus your mind is freed from its worries and tensions.

Pastels

Such a *beautiful* medium and one offering such brilliance and such a variety of colours. The duller shades are more suitable for the basic wildlife studies; lots of greys, grey-greens and buff colours, with a small selection of brilliant, lively colours for the more exotic birds. Personally, I use a lot of black.

As with all the media there are so many ways of using pastels, and it is fun, as Degas did, to experiment with different methods and apply them to the subject in hand. I usually use them in an 'open' manner, allowing the paper to show through and do a lot of the work; a more 'suggestive', method, perhaps. However, sometimes I find the subject demands a much more solid treatment, and the pastel can then be rubbed in and used as thickly as paint. This method I usually employ when I am sorting out a pattern or a decorative type of thing. Another advantage of this medium is that it is very good in admixture (pastel over watercolour or acrylic, mixed with Indian Ink, used over a monoprint). All sorts of concoctions which used to be frowned upon can be used these days.

As one becomes more experienced, one starts to see the subject in the terms of a specific medium and certain birds and creatures lend themselves especially to the use of pastel. Sometimes, of course, it is used simply to 'cover up' or 'patch' a watercolour that has not quite succeeded, but mixed media done with intent can be very effective.

Always break your pastel sticks up into small, workable pieces and use them on the *side*. Never press very hard until you know exactly what you are going to do. Feel your way in because, although it is possible to move a mistake either by the use of a coarse brush or with a piece of putty rubber, it is not easy and the first bloom or texture of the paper can be lost.

Tone values are obtained by the varying pressure you can put on to your

28

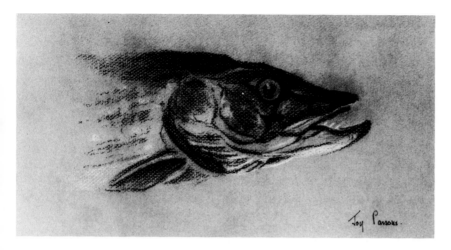

bits of pastel; sometimes if a sharp edge was needed I used to rub the round pastel down to one on a piece of sandpaper. Now, however, the square-edged type of pastel is available although they don't seem to me so 'feathery'.

Don't forget to have some form of pad under your pastel paper between it and your board or else you will find the grain of the wood or other marks come through in an extraordinary manner. It is a good idea to put a thick 'wodge', consisting of several layers of newspaper, on to the board and then fix it permanently down with gumstrip. It means having a special board for the purpose but is well worth it.

Paper is very important with pastel work as it can play such a large part, particularly if the 'open manner' of working is used. I prefer the Canson to the Ingres as it has a coarser grain and is tougher altogether. By the way, you can always tint your own watercolour paper to give any colour scheme or effect you desire. Sugar paper is quite adequate for rough studies but will fade.

To fix or not to fix? Personally, I do not. It spoils the lovely 'feathery' look sometimes obtained and, if stored between newspapers or tissue, the picture will keep surprisingly well. When I want to transport unframed pastels, I lay them on to a sheet of clear cellophane, face downwards, and bending the edges over, I tape it down on the back. This prevents rubbing.

By the way, even if the model has disappeared, pastel is most useful for making notes of the leaf shapes, branches, grasses and flowers etc. Half the charm of a wildlife subject is the position and manner in which it will present itself amongst the foliage.

There are so many tints and shades amongst the various pastel hues that I decline to give you a list of colours but I do suggest that the two boxes now available containing the different shades of greys and browns are a very good start. To these you can add what you will. Try to keep the different groups in different boxes or compartments; they become unrecognisable if kept jumbled together, although they can be cleaned up and freshened wonderfully by shaking them in a jam jar full of rice.

Naturally, if painting flowers, you will need a much larger selection of

18 This is a direct pastel study done on Canson pastel paper where the coarse grain showing through in places helps to give the 'fishy' look to this handsome pike. This is a case where the eye was the first mark to be made and then I worked out directly from there. The tone values, of course, are produced by the varying pressure on the pastel.

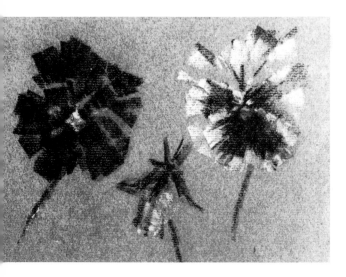

19 A fairly crisp treatment of pansies here with ordinary soft pastels on Canson Paper. Then, by comparison, the same crisp treatment with oil pastels, those much maligned things which I greatly enjoy! You will see that you can get just as much brilliance as you can with the soft pastels and with the added advantage that they do not 'rub' or, rather, smudge so easily.

bright colours although the greys and grey-greens still come into their own.

As always, and in whatever medium, I do the 'donkey-work' first, building up the surroundings and the paler or fainter blooms (those behind or in the distance) and then the excitement of the impact of the final touches last – bread and butter first, jam and cake at the end!

For a beginner, pastel gives such a quick response that it is very exciting. It is also important, as well as your ordinary stick pastels, to have some pastel pencils for fine work, say the eye or eye-rim of a bird, the hair tips in a squirrel's tail or for details in the centre of a flower if you should so desire. On the wildlife side I suggest as a start an ochre, a brown, a black and a white – you can go on from there if you wish!

Oil pastels

A comparatively new medium this, and for some reason not a very popular one; I cannot think why, as I find them invaluable. You can use them for quick sketches of anything and everything and they need only the minimum amount of space to carry. Admittedly a good deal of experimentation was needed when they first appeared on the market as there were no hard and fast, or time-honoured ways of using them and many a box is still lying tucked away in a drawer for lack of effort. The range of colours in the smaller boxes is rather limited and crude, though they can be blended. The largest one on the market, however, contains about 48 pastels and gives many more subtle shades and tints, and so is well worth the extra outlay if you intend to press on with them. They have several advantages over other media which are worth considering.

1 Ease of transport. They are very light, which makes them ideal for travelling.

2 Great versatility. They present many varied approaches in their own right and many more in combination with other media.

3 They are difficult to smudge after application and, therefore, do not need

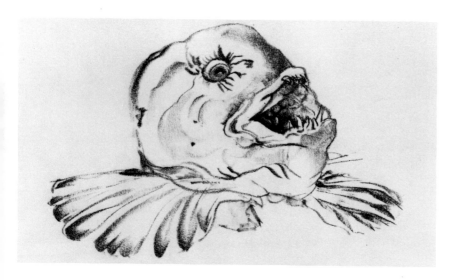

to be fixed. (In all fairness, however, I must also point out that they do not rub out.)

4 Compared to the cost of other media they are relatively inexpensive.

They come, of course, either round or square. My own preference is for the latter, but it is purely a matter of personal taste. As with all the other media which we are more used to, there are countless ways of using them; the thing is to find out which shape, method of application and type of paper suit your own individual reactions.

My own outfit is utterly simple and consists of small bits of each colour (extra pieces of black in my case, as I frequently use it), all carefully fitted into an old Koh-I-Noor pencil tin, a little cotton wool, a little turps (pure) in an aspirin bottle, and all contained within a small make-up case with a zip fastener and, of course, whatever sized sketchbook takes my fancy or is convenient at the time. All can fit into a handbag or pocket if necessary! Looking through my portfolio in connection with this book, I have even surprised myself myself by the number of times I have used them to collect shapes, impressions, ideas and close-ups; most of the working drawings for my large tropical bird murals (*fig. 24*) have been carried out in this medium before adaptation to acrylics. I always keep a small set handy in a pocket in the car for emergencies, complete with sketchbook.

Direct use, drawing and painting in the same operation, is my usual method and I am happiest on very smooth (usually Daler Lay-out pad) paper as they 'glide' beautifully on it. The wrist comes into play a lot as you'll see from the various strokes (*fig. 20*). Always break them into small pieces and, in general, use the *sides* and not the points, as with soft pastels. Tone values, like the ordinary soft pastels, are obtained by varying the pressure of a stroke. This will come with practice. Always work tentatively at first as they cannot be rubbed out.

Try using a comfortable sized bit of pastel and learning to press or release pressure first with one end and then the other without lifting it off the paper

20 My oil pastels came into their own here on smooth Lay-out paper. I had decided to spend our short holiday in Norfolk encumbered only with oil pastels and my tiny paintbox; it worked very well and proved the convenience and versatility of this medium. This was the head of a catfish which was propped up in Lowestoft Fish Market with the following notice written above: '*Warning:* This is the head of a passer-by who did not contribute anything!' (Contributions were for the seamen's box.) I used black for nearly the entire drawing with just a few red and orange touches to show the 'gore'. This drawing appeared with others in *Leisure Painter* under the title 'East Anglia plus Oil Pastels'.

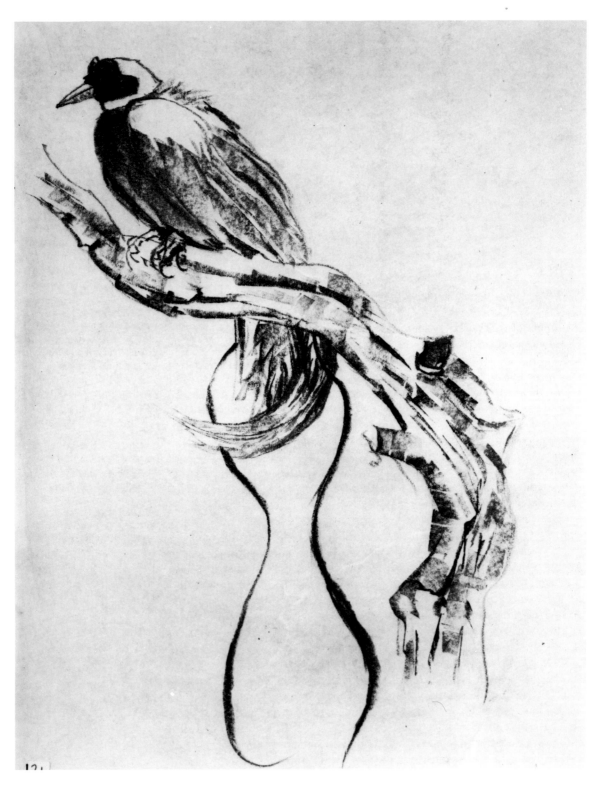

(roughly forming a figure of eight with it). Hence my preference for the square type as opposed to the round ones, because one can get a strong band of colour and, with a quick switch to the angle of the pastel, a very fine line, or, if necessary, use one of the four points at each end.

If you are an oil painter by nature, it may appeal to you more to 'lay a wash' of colour which may be obtained by rubbing the first application with a little cotton wool or rag soaked in turps or, alternatively, by using a brush, and then working to the desired effect and strength on top of the first application. If you decide to use this approach, don't forget to place a piece of plastic or paper padding beneath to prevent the turps soaking through to the next sheet if you're working with a sketchbook or have several sheets on your board!

Periodically you will find it necessary to wipe your bits of pastel and your hands clean with a 'turpsy' rag when you are working. A bit of Blue Tack will also clean them up though it won't rub out. If the pastels are out of their original box, keeping them in corrugated cardboard will help to keep them in good condition.

Acrylics

Whilst some people rave about acrylics, I still prefer my watercolours. The advantage of acrylics, however, is the fact that they are very permanent and can be used either like oils or watercolours and have none of the unpleasant (some people love it) smell of turps. They dry very quickly and the brushes must be washed immediately after use. This can be advantageous or disadvantageous according to the stage of development at which you find yourself; if advanced, you know what to expect in the way of drying and it is nice not to have a wet and sticky painting to carry home if you are out sketching, but if you are a complete beginner my advice would be to leave them alone until later.

My own experiences with them have been varied. Some are included in

21 (*opposite*) Direct use of oil pastel here on this exotic bird of paradise with its brilliant red tail and black 'streamer feathers'.

22 (*above*) Oil pastels of toadstools. Here you see I have worked on cartridge paper and enjoyed some fine line work with the extreme edges of the square type pastel. The first wash of colour was rubbed in with turps before the finer drawing took place.

33

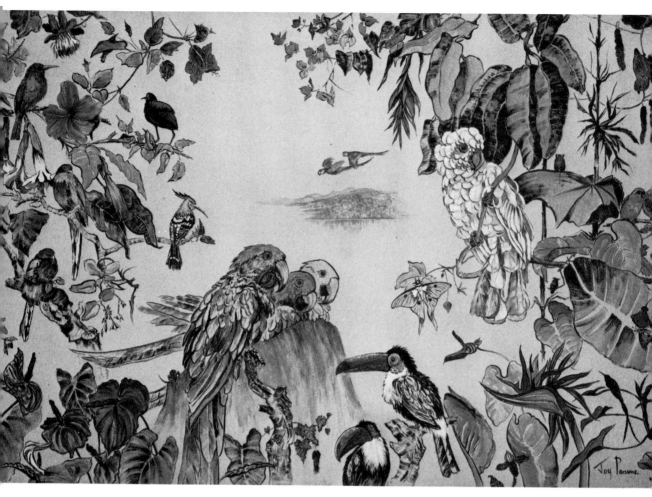

23 This mural (in the collection of Mr Desmond Taylor) was painted with acrylics on a grey-blue base and was done from my various drawings. (*Photograph courtesy Harold Morris*)

24 Section of mural for 'Birdland' (commissioned by the late Mr L. W. Hill), showing also two more of the five sections in the background. It was painted in a similar manner to the previous example. Directly behind me is a baby penguin! (*Photograph courtesy Bournemouth Evening Echo*)

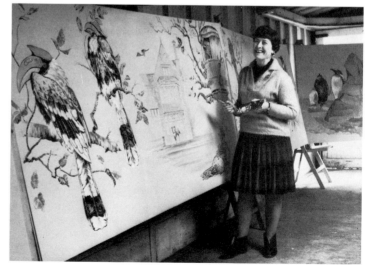

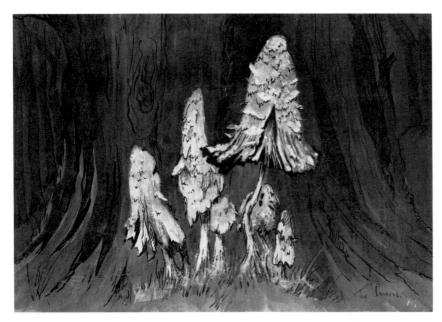

25 This is a collage painting, which I put together from a sketch of a clump of shaggy inkcaps that I found up in Cumbria. I decided on a collage as the tufts on the inkcaps suggested so strongly tissue paper. As I found them at the base of an enormous fir tree I used this base as a background, cutting varying strips of colours and pasting them down. Behind this I used blue tissue with thin purple strips to represent distant trees. I painted the main shapes of the inkcaps and then pasted a sheet of clear tissue over the lot. On top of this I added the 'fluffy' bits of tissue that stand out and drew into it all with Indian Ink and touches of white paint on the toadstools. A somewhat laborious but enjoyable exercise!

this book, whilst others, being large murals, are not. When involved with the murals I painted the whole thing with just two brushes – a No. 6 and a 'flat' – and just kept washing these two so that I did not forget this chore! It is fascinating to put one thin, transparent wash over another and to see the brilliance build up. On the other hand, I use them rather in the manner of my pastels on the larger scale, with a great deal of black and impasto patches here and there; you will see for yourself.

Fig. 24 shows one of the five sections of the 40-foot mural being painted. Each section was done separately in my studio and joined up afterwards. It was one of the most enjoyable episodes of my life – all the drawings were done in the bird gardens and utilised in the studio later. Some of the larger birds, such as the huge hornbills, had to be done in two sections.

It is impossible for me to offer advice as to which medium an artist should use; it is up to you to experiment. I can do no more than say I always feel one should try a new medium at least three times before abandoning it in disgust. Perhaps some of my impressions and attempts may tempt you to break into another painting area.

Experimental Techniques

Are you texture conscious? If you are, there are many ways of exploiting this consciousness.

Waxing
The best known of these methods is waxing with a piece of common candle, or an oil pastel if colour is desired, or even a little of both. Simply rub the desired image on a roughish paper (Arches is admirable). It is sometimes difficult to see what you have drawn with a plain candle, so bend down and look at the board sideways and then you'll be able to see the shiny lines. Watercolour and/or ink can then be flooded around and over the waxed area which will give a pleasant 'mottled' surface where the colour does not 'take' on account of the wax.

Off-setting
This is another fascinating technique. This can be done with oil, gouache, printing inks, or even pure watercolour. Have your pigment on the thick side, tear a little bit of newspaper or similar into a random shape, dab it onto your paint and quickly press it down on your work where you want it. You can also get a crisp, fine line with a thin card dabbed in the paint and then pressed off smartly. The paper can, of course, be cut into exact shapes if desired.

Painting with rollers
Random backgrounds can be produced with the aid of rollers. First squeeze out some lino printing ink – I prefer the watercolour base as it is so much easier to clean – on to a flat surface (glass preferably) until the roller is nicely covered and then roll it off around the masked shape which you wish to preserve and which you will already have cut and fixed lightly. Then print off and remove the mask afterwards. From here on you can proceed normally. Alternatively, you may wish to cut out a stencil and use the roller within that, protecting the *outside* area instead. There is room for much experiment.

Glass
You can paint directly on to glass and print, or cover the glass entirely with paint and 'subtract' your picture with a sharp instrument or what you will. Don't forget that what you print off in this way will come out as a mirror image. A piece of glass is 'an open book' for experiment.

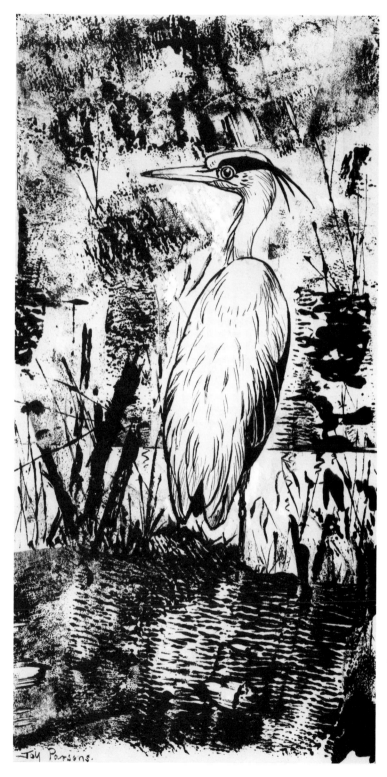

26 A 'rollered' background and then a careful study of the heron, observed from a neighbour's garden. Watercolour Printing (Lino) Ink used.

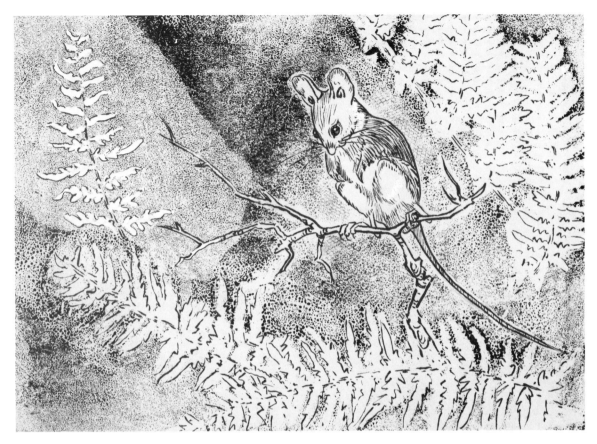

27 An experimental one of Willy woodmouse. This is half a monoprint; a mask was cut for the woodmouse and the other oddments were inked up and arranged, and then a print was taken. It was all carefully sorted out on a piece of glass for printing. The woodmouse details were then put in afterwards. The original drawing for this was done in the small hours of the morning when I switched on the light and there was the mouse poised beside my bed in his dry aquarium. The best subjects always seem to turn up at inconvenient times.

Whilst all these techniques are very exciting, it will be found that nothing takes the place of hard work, drawing and observing, and one must beware of doing too much 'way-out' work and so get too out of practice with the academic approach; the trouble is to 'keep all the pots boiling' at once.

Having explained these various experimental techniques, I would like to stress that if we only learn to use our eyes as they can be used, we will find subjects and backgrounds supplied ready-made by nature that need no more than realisation. For instance, if you examine and search the surface of things like tree bark, crumbling walls, tombstones, shells, etc., you will find them all bristling with designs equal to any abstract expressionism – it just remains for you to 'site' them and portray them, always bearing in mind the focal point.

Choosing
Subjects

Mental Approach

So much of a painting is, or should be, I think, created first in the mind. You see something that inspires you – a bird, a flower, an effect. Immediately you start to visualise it on paper; then the queries arise: what paper? what medium? with or without background? Try to sort out what it is exactly that appeals to you: the atmospheric effect of a heron in the morning mist; a blossom in the sunshine; the colour of a toucan's bill; the glorious colour of the leaves of the mangold plants in the fields of autumn; sparrows fighting; silhouettes at dusk. Try to get a clear-cut idea of what you want to create before you put a brush to paper. Muddled ideas are the beginner's main downfall. Decide upon the focal point and keep it in mind at all times. Then think about the traps and difficulties the subject and its chosen medium will present and decide how to tackle them. Like a surgeon, the painter should always go around analysing, diagnosing, dissecting visually and mentally and, after all this, operating! We set off full of hope, with a lovely, unblemished sheet of paper or canvas in front of us, waiting for inspiration, but it can happen sometimes that our ambitions over-reach our capabilities; the only answer to this is to keep on trying. Never forget that it is up to you to signpost the direction of the onlooker's eye; *you* can lead it wherever *you* wish.

Sometimes I have heard people say: 'I don't know what to paint,' and I am very sad for them – how can it be? With all the world around us, full of light, shapes, flowers, insects, birds and creatures, how *can* it be? The desire to paint is, or should be, the desire to express something, to portray one's reactions to something seen, to record that moment in time before it escapes our decreasing memories. If a person cannot find a suitable subject, then he is perhaps painting for the wrong reasons; maybe the answer to my question lies here.

Suitability of Subjects

Being prepared

Most people have, at some time or other, attempted to draw their pets or domestic animals and, although this is very good practice, they do not present the same difficulties in trying to catch a pose as does wildlife.

Most creatures will respond to food and kindness, and birds and hedgehogs can easily be encouraged to appear at special feeding places in the garden or near a windowsill. (Always have a sketchbook and pencil close at hand near your window, or any other place you are likely to get a 'sighting' of something interesting. I try to keep paper and pencil or pen also in our greenhouse in the garden, in a pocket in the car, and I have sewn a special little pocket inside my hard-working anorak to house my tiny book, as an alternative to my handbag.)

You must be prepared to get the outline of perhaps only half a bird or merely the angle of the legs in relation to the body, or a head, at one glance; you will then probably be able to get the missing bits at the next appearance, or even minutes later. It may be a help when dealing with a bird to remember that it came from an egg; this is a very good shape to commence with – you can add the 'refinements' afterwards. With experience you will learn to join the bits up correctly but, unless you are fully acquainted with anatomy, it is a case of learning to observe correctly and, as I said before, patience! If you are keen, however, you *will* learn something about a bird's anatomy – it helps to work out the positioning of the legs, if nothing else!

It is useful to collect studies of beaks, legs and feet and so on, which can be 'put together' or used for correcting something that doesn't look right on a quick sketch. The wing of a dead bird is a very useful reference to keep as it will help one to show the primary and secondary feathers correctly. Whilst these may be simplified in a final, say watercolour, rendering, the indications should appear right.

28 When trying to draw a bird, you may find it helpful to remember that it came from an egg. If you practise taking an egg and drawing it from different angles, you will then find that you can add the extremities and feathers, etc. afterwards. I have used a mixture of pen and pencil here so that you can see what I mean. This approach does not help of course with the leg anatomy and must not be allowed to stop you really studying the birds but it *is* a way of starting!

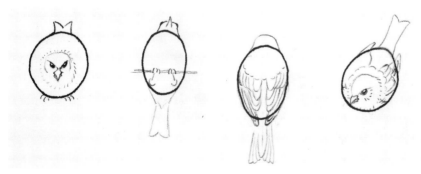

29 A page of 'oddments' taken from sketchbook studies: young blackbird's chest and spots; warbler's head – all I could get of him in the garden; two birds' wings – those of a thrush and a dunnock, taken, of course, from dead birds – always a sadness but they must be used; a baby mallard, and a butterfly.

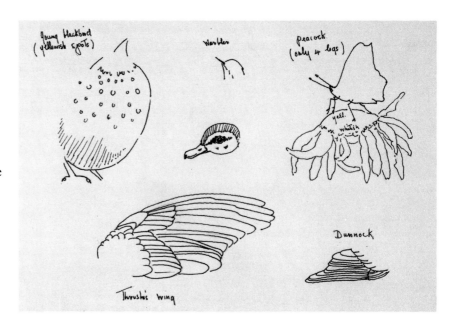

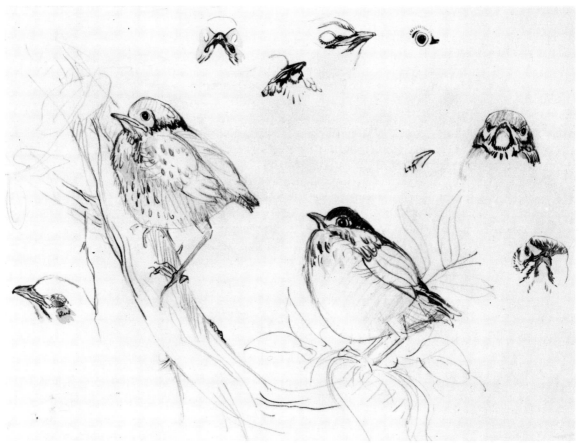

Choosing a subject

As with human beings some creatures or birds make much better subjects than others. It all depends, of course, when deciding upon your subject, what part of the country you live in and what are likely to be the local inhabitants. I have, so far, followed the principle of taking what comes my way, with a few expeditions to zoos and bird gardens from time to time, for some of the more exotic attractions. The joy of this sort of work is that all the time you are getting involved with the creatures and learning more about their lifestyle.

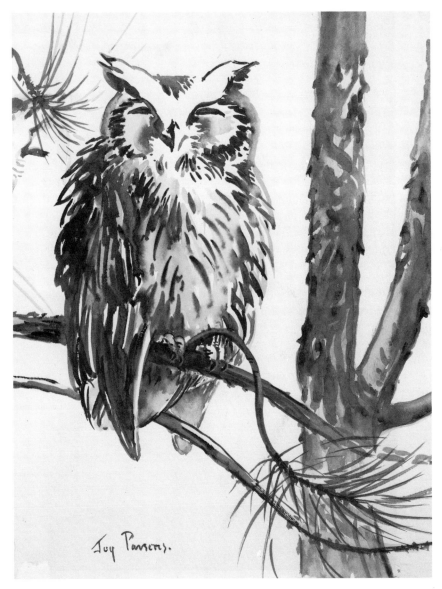

Joy Parsons.

30 (*far left*) Young thrush sketches. These were obtained in our garden. The bird was several days old here as its beak was bluish instead of yellow. Pencil studies with a touch of colour here and there and notes of the direct facial expression and markings. All these notes have been useful for checking at other times with other young thrushes.

31 (*left*) A 'quickie' of a scops owl done in a bird garden, using Payne's Grey from my tiny box of watercolours and my folding brushes.

43

32 Coatimundi. This, of course, is a zoo drawing, done with pastels. Having his siesta on his tree stump, he ignored me and stayed put.

Garden and wild birds

Owls make wonderful models as they remain static for such long periods, and young thrushes are also very good, as they tend to 'freeze' at the sight of you. The collar doves which have now colonised here are pretty, gentle little birds and these are around in such quantities that they must surely be available to everyone for sketching purposes. Everybody, at some time or other has the opportunity to study a blackbird at close range, and these handsome birds are one of my favourites. They are at their most spectacular when seen perched on a twig laden with blossom (usually apple), and the beginner will find that using flowers and berries as 'surroundings' will help considerably to make the bird or animal more realistic.

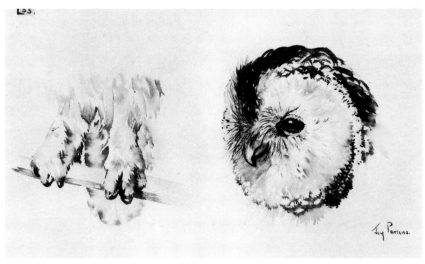

33 This lovely barn owl was brought to me in a sorry state, having been run into by a car, so I had to 'adapt' myself to the circumstances and just did a close study of his head and feet – he had lost one eye. This was a good opportunity for watercolour work – wet bits, dry bits, loose bits, fine bits.

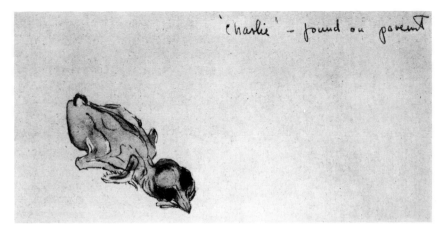

'charlie' — found on pavement

34 Poor little oddment! Found on a pavement, having dropped out of a high nest apparently, and brought home to me by one of my Sketching Party. I kept him alive for two days in my locker, but he didn't quite make it.

35 These two illustrations are notes waiting to be made into paintings when time and energy (of which there is never enough) permit! The blackbird was scavenging in the bottom of a waste-paper basket in a public car park. The second one, which I shall call 'Confrontation', took place in the snow on our bird table – collar dove and blackbird.

45

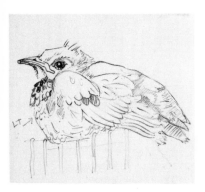

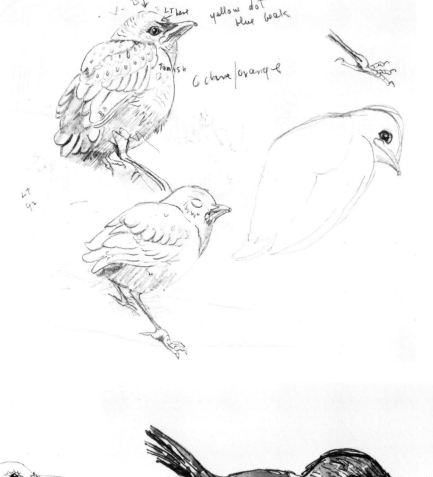

36 Young blackbirds. One was in our garden and sat fairly obligingly for me; the other, sitting on the edge of a cage, was an orphan brought up by a friend and which stayed around the house and became quite tame for a very long time. Things like this eventually get turned into paintings and it is a joy to have the records.

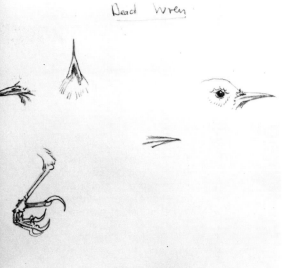

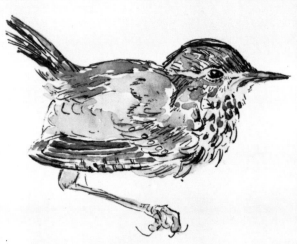

37 Dead wren. I found this little chap lying in the road – presumably hit by a motor car – so I made as many little notes as I could with pencil and pen and a slight tinting of watercolour. Such delicate little legs and feet and a *very* long, sharp beak.

46

38 Nothing to explain here really; just a drawing but of a very beautiful bird – a Victoria crowned pigeon. There is an acrylic of him also.

39 Study of a young bird in a lilac tree above my head – I think it was a goldfinch.

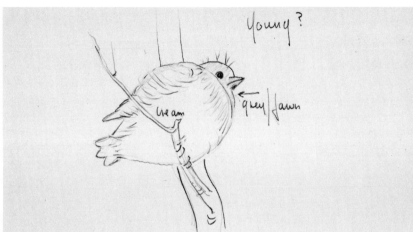

Young?

cream

grey/fawn

40 A close-up study of the golden pheasant's feet and legs.

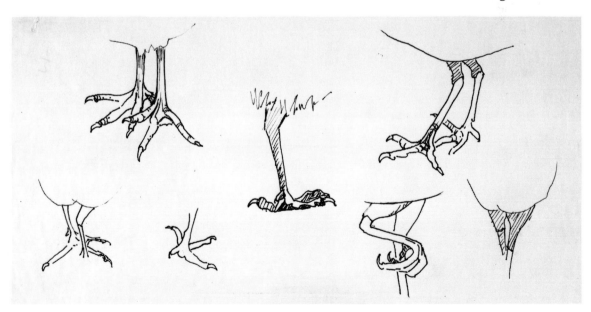

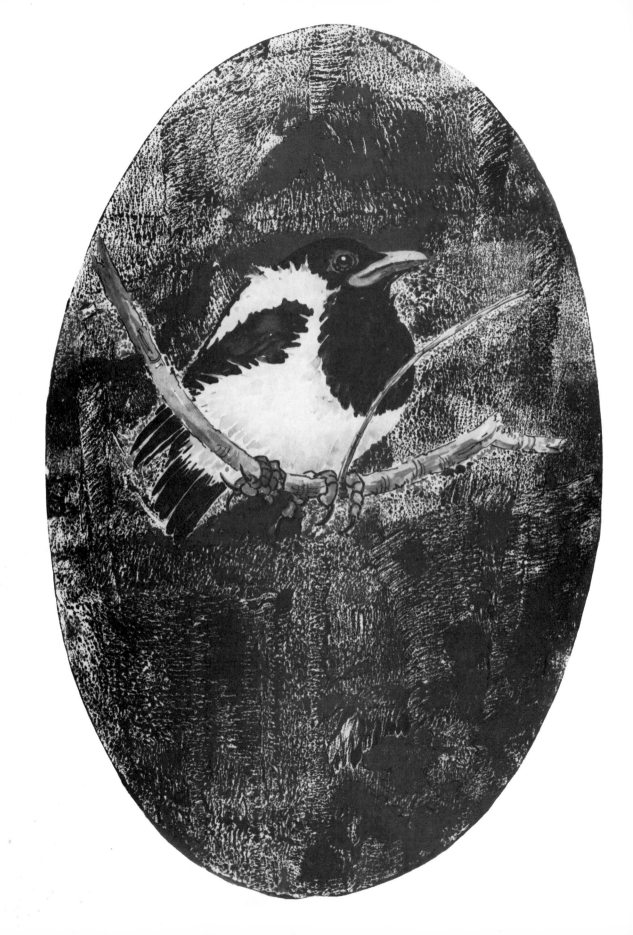

Many wild birds can be used as subject matter; it is just a question of building up a relationship of trust with them so that they will come close enough to be studied. Our golden pheasant cock, for example, which was hatched from an egg on a hot-water bottle beside our bed, has given me plenty of opportunity for 'close-ups' of legs and feet, etc. (*fig. 42*). His story is told later (*see pp. 94–99*).

Wild mallards are so much a part of my life here by the river Avon that it is quite usual for me to look out in the early morning and see a pair of ducks on my neighbour's roof. They will be deciding on and fighting over our various nesting sites, usually made from apple boxes covered with cellophane, which my long-suffering and co-operative husband used to erect. These boxes are considered highly desirable residential properties. In recent years the demand has been for higher and higher sites – tops of walls, trees, clematis arches, and so on. One reason for this is probably to keep the ducks out of reach of predators, such as the marauding cats, foxes, and mink, with which they are always troubled. There are often too many amorous drakes around for the number of hens and the males have no qualms about bullying the hen off her nest at times which can often prove disastrous. Demand for these boxes often exceeds supply but we do our best!

41 (*left*) A young magpie perched long enough in a neighbour's garden for me to get drawings, and afterwards he was painted on a mono-printed background as an experiment.

42 Careful studies of two dead birds; one was a little dunnock and the other possibly a pippit. You will see the sort of notes I always make beside the drawings for future reference.

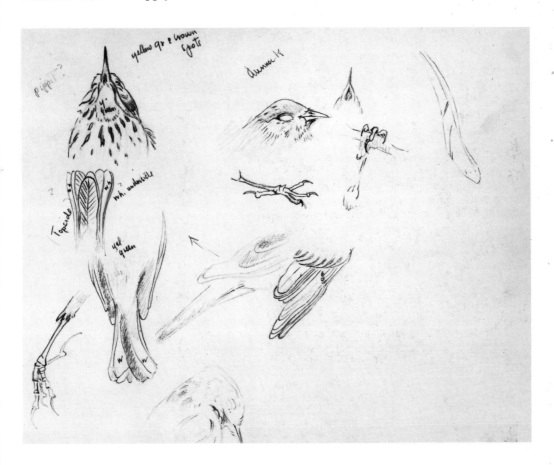

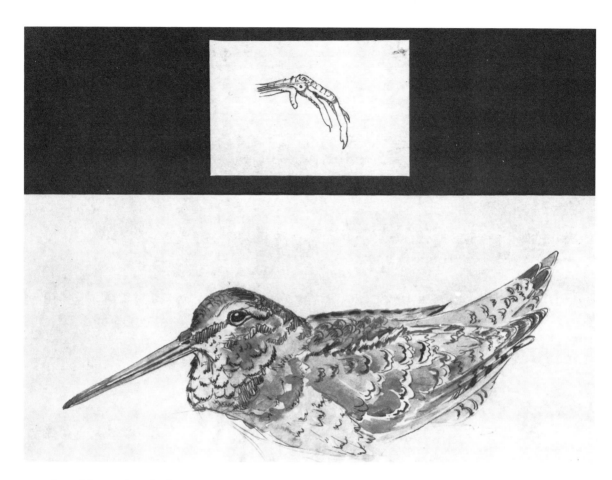

43 A rapid note done in the studio from a recently dead woodcock that was brought to me; a pencil sketch with a little colour wash added.

44 I managed to get some heron studies from the window of a friend's house – handsome birds but very wary. I got this effect before the oncoming storm broke, working from notes.

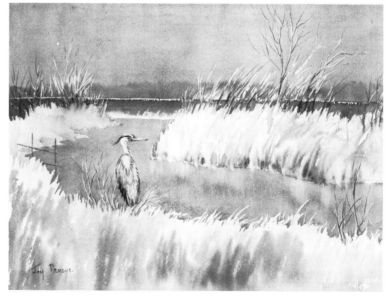

50

All are possible models, of course. The adult hen mallard is rather a labour to sketch as the female plumage is very intricate, but there is nothing quite so appealing as a baby mallard (*see fig. 127*). In the midst of organising myself for this book I took time off to nurse a youngster from one of our nests on the wall. Always smaller than the rest, I noticed he was swimming with one side only. Rescue took place and by next morning the scrap could only move his head. 'Due to enteritis,' said our wonderful vet. 'You could try antibiotics.' So I did, and after two sleepless nights was rewarded. Gradually the duckling recovered and as Mum and the family were still coming up for food each day, I showed the invalid to her each morning to keep up the contact, and when he was well enough to go back she actually accepted him. This is unusual; so often a mother will reject a chick after an episode of this kind. The youngsters, however, bullied him sadly. He had a normal river life of just one month and then a sudden gale and strong river currents carried him off. Just another heartache; the survival of the fittest. I got one sketch (*fig. 45*).

45 The lame duck we managed to nurse back to health and restore to its mother.

Exotic birds

I have been extra fortunate in having access to a variety of humming birds, some of them very rare (*figs. 46–49*). When first I saw them they were flying free in a large area of luxuriant foliage and luscious flowers: sadly as they are so territorial and so many fights ensued they had to be confined in smaller spaces – sad for them but it made life much easier for me!

Apparently, the first live humming bird to come to Europe was in 1965 where it was seen in Regents Park Zoological Gardens, but, as nobody knew enough about correct care and feeding habits, it died. Humming birds are the smallest birds in the world and unique in that they can fly backwards. In plunging flight they can reach 60 mph and the frequency of their wing beats can be as high as 200 beats per second. In order to achieve this speed, their wings beat forwards and backwards, not up and down like our well-known birds. So their wing structure is quite different from other birds and they also have inordinately long tongues, sometimes longer than the bill itself. It is necessary to be aware of these differences when attempting to draw them. They are like diamonds with the sun on them. The irridescence of the feathers is caused by the reflection of light, we are told.

If, in a tropical house in a bird garden, you can manage to get your model complete with flower spray on which he is perched – so much the better. I have been able to use many of my notes and sketches of tropical and exotic plants in conjunction with these little birds but, in composing a picture, it is important to take care that the blooms are suitable for the birds; nectar, of course, is the attraction.

On one occasion it took me several hours in intense heat in a tropical house to get my first drawing of a ruby and topaz humming bird, and I was exhausted at the end of so much concentration. Then this minute creature took a fancy to my multi-coloured woollen scarf and tried to pull bits out of it with a view to nesting material, presumably. It was totally fearless of me.

46 These humming-birds were drawn in the tropical house of two well-known bird gardens, and represent many hours of study. They are, starting with the top left-hand a frilled coquette, a streamer-tailed, a raquette-tailed, a female streamer-tailed, a ruby and topaz, a long-tailed sylph, a buff-tailed coronet and a rufous-tailed amazilian.

47 (*opposite above*) This was a frantic effort to try and catch the raquette-tailed bird in flight; pencil and a touch of colour on one of them.

48 (*opposite below*) Allowed to stay in my special bird garden until dusk fell, I was delighted to find these five hummingbirds firmly perched and sound asleep; they sleep with beaks pointed upwards, not head-under-wing position. Straight brushwork from my tiny paintbox again, mostly Viridian Green and Black as they appeared against the failing light.

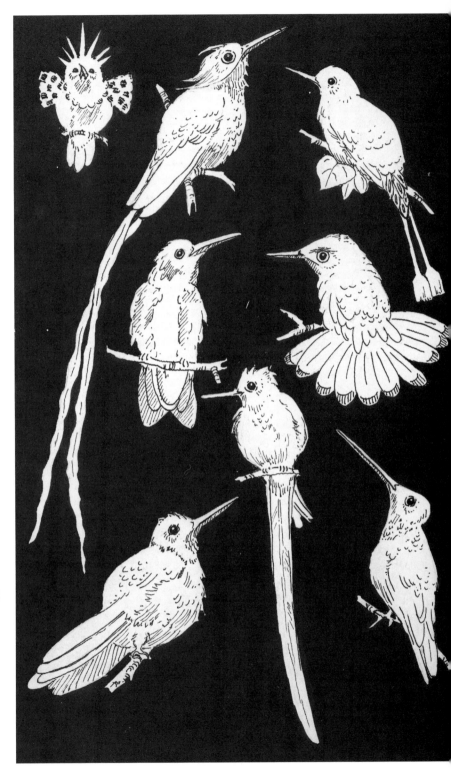

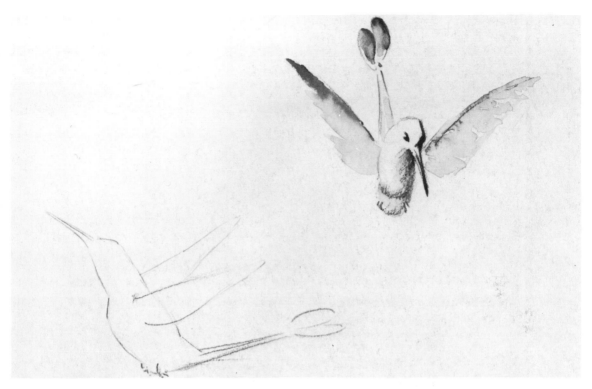

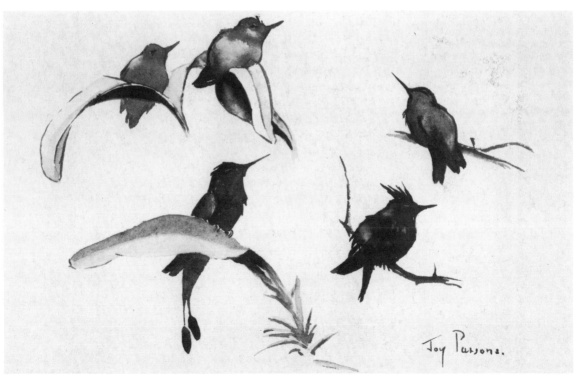

53

49 These are two
streamer-tailed
hummingbirds.
Scintilating and elegant
creatures. Watercolour
on a variegated wash
background.

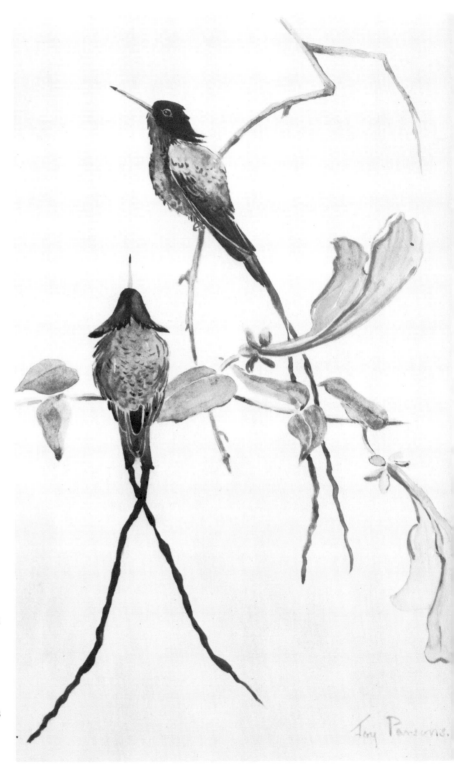

50a (*opposite*) This is
the long-tailed field
mouse and it is a very
beautiful little creature
with its large dark eyes
and very long tail. Its
large ears are one way to
recognise it. These were
pencilled notes with a
little colour added. You
will see the sketch with
the face and feet facing
you which were up
against the glass sides of
the little dry aquarium
in which it was housed
temporarily.

50b Another field
mouse. These pen
sketches were made with
a Stabilo Superfine pen
and an ordinary Stabilo.
In this case the mouse
was just dead – sadly we
had to set a trap as he'd
got into one of the
drawers in my plan press
and had a good meal
from some of my
sketches.

Garden mammals

The little bank voles which live in our garden and to which I am particularly attached, have at intervals been painlessly caught and housed in a special large glass house filled with peat, earth, twigs, leaves and berries and in which they seem to thrive. We provide lots of earth so that they can burrow and plenty of material to make their nests with, as well as museli and apples to tickle their palates. After a short period, when I have obtained a bookful of drawings, they are released again. Fortunately they are short-sighted which helps when trying to draw them (*see pp. 121–123*).

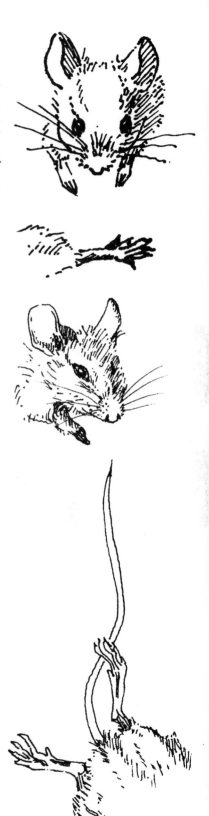

Moles can hardly be described as inspiring subjects, but they do provide good practice. I remember picking up a heaving pile of leaves one day as there was obviously something alive and, as usual, was keen for a new model. I got a sharp bite as a reward as a mole surfaced, so don't be too rash. Another surprise was a bat which one day fell at my feet – from heaven, apparently. I can only presume it was dropped by a predator. Brought home in a pudding basin, it gave me an unusual close-up (*fig. 51*).

In the case of a hedgehog it is important to notice the angle at which the spines stick out, and how they change as he curls up. My principal example is 'Henry' (*figs. 106–111*) who was found on a main road with an injured leg, brought home, de-fleaed and put into my famous glass house for first aid, food and shelter, during which period he supplied me with many useful studies. But more of Henry later!

Squirrels are available in woods and parks (if you live in the North you might see a red one instead of the usual grey) and, although one might dislike their predatory habits, they are very attractive as models.

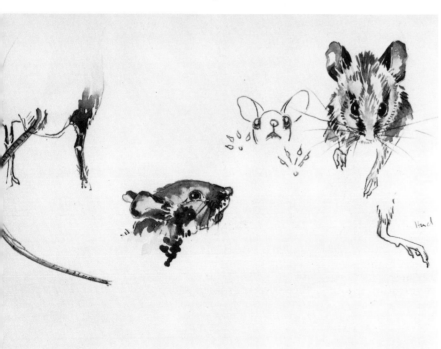

55

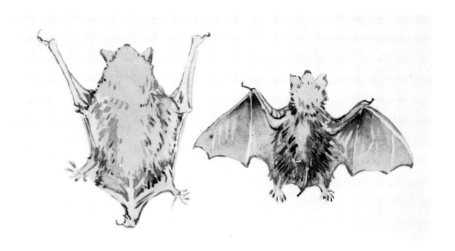

51 Here are two bats. The larger fell out of the sky and the smaller one was found clinging to the warm brickwork of a friend's house. *Not* my favourite creatures but interesting all the same and another shape to be dealt with.

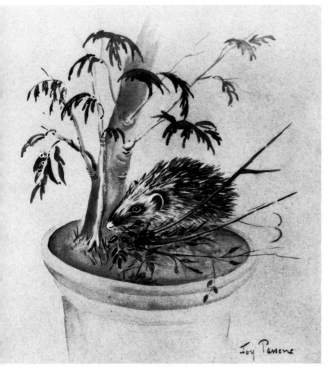

Joy Parsons

52 This little chap was 'free-lancing' in a large greenhouse and finally came to rest in this pot with a small tree in it. I made a quick sketchbook note and got three-quarters of him down before he took off. The plant and tree being stationary, I carried on with them and finally did a painting from the drawing at a later date. Again, gouache has been used, thinly and thickly as you will see.

53 This particular hedgehog was interrupted during his winter hibernation in a comfortable nest in our bed of ferns in the garden by the winter floods which rose to unexpected levels and 'ousted' him.

56

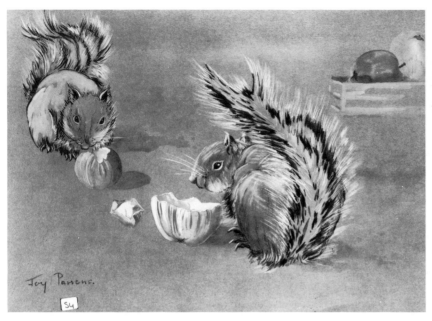

54 Such pretty things, these squirrels, but such terrible predators. This chap was enticed into a trap by an apple and I kept him spitting and eating alternately for a short time while I made several drawings. I used gouache and the Art Cover paper for this painting, treating it softly but enjoying myself with the thicker colour when it came to his bushy tail.

55 This was a lucky sight – two young fox cubs playing in a friend's garden, only a stone throw away! The top right-hand drawings were spotted on Exmoor and the two 'portraits' were of an unfortunate creature that had been run over.

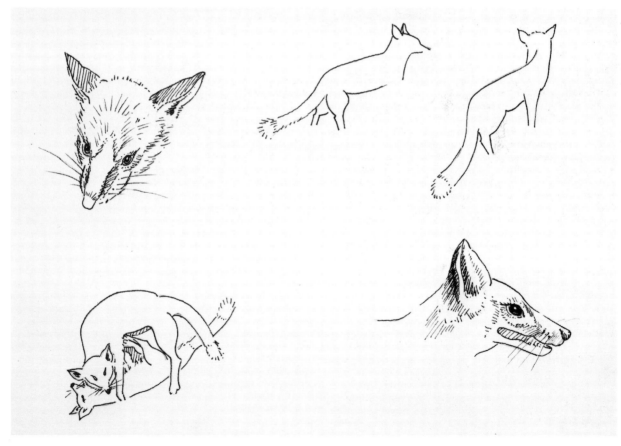

Amphibians and reptiles

Toads and frogs, both of which I find delightful to draw, are often to be found in gardens and ponds, though I hasten to say that, owing to the use of so much land for building purposes, it is getting increasingly difficult to come across spawn or tadpoles. I was amazed, incidentally, at the different expressions of the tadpoles under the magnifying glass when I made the enlarged version. At one time I decided to record the life cycle of the common frog and common toad (*see p. 127*).

Newts also make fascinating subject matter (*figs. 138–141*). When I went through my 'Newt Period' and decided to get the full cycle of their breeding session, I kept their aquarium on our dining table with a magnifying glass very close to hand so that every new position could be jotted down, sometimes on envelopes or bits of paper if I was (shamefully) caught without a sketchbook and the post had arrived by breakfast time. This went on for about six months after which time I began to think some of my friends looked rather like newts! But the occupants of the aquarium had become completely used to my peering face and I even got the little palmate newt, whom we had christened Salome, laying her eggs on a leaf and carefully turning it over for camouflage afterwards, right in front of my nose! All this performance meant lots and lots of drawings which eventually were traced off and put together on one big sheet. Each new position I managed to register gave me so much satisfaction. The New Forest ponds where I first obtained my newts have long since disappeared for road widening, as is happening everywhere, but at least I have my precious records.

I had the greatest fun on one occasion when somebody lent me a chameleon for an afternoon. He spent most of the time watching the river go by out of the window whilst I drew him. Then I tried altering the scene to see him change colour which he obligingly did three times. It was fascinating to watch his enormous eyes rolling completely round, but they were very tricky to draw (*fig. 57*).

56 This is rather an unusual one: a young adder which my husband brought home in a matchbox – dead, mercifully, though I can't imagine why. A brush drawing, this.

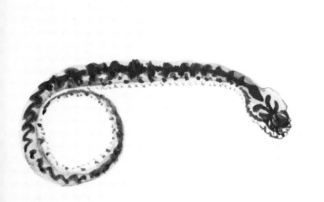

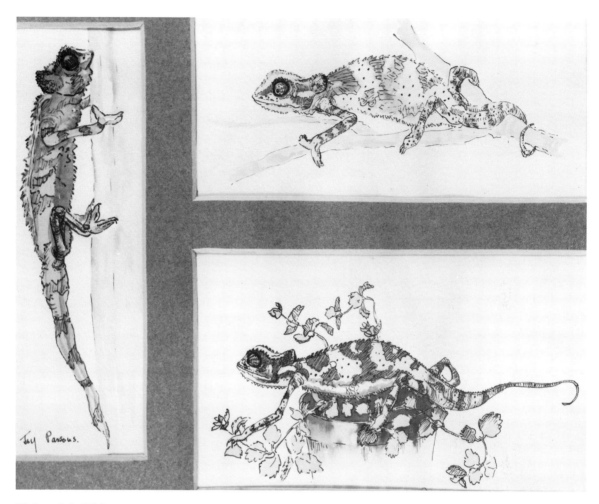

Fish and shellfish

Aquariums and their contents have great possibilities; the only snag is that usually one has to work in a very poor light, but it is still worth it. There is a great variety of subject matter to be found there. Recently, a masked crab caught my eye (*fig. 62*). All I could think of when I spotted him was my yoga; he is sitting in such a beautiful lotus position! Fish of all kinds offer endless opportunities for drawings. As my husband was a keen fisherman, he used to present me with models from time to time, some alive, some dead – all good practice.

Insects

Caterpillars, moths and butterflies open up yet another world to the painter of nature and one often doesn't have to look much further than the ground under one's feet for potential subject matter.

57 Chameleon. I was lucky to get such an unusual model; he was loaned to me for an afternoon. Knowing how they camouflage themselves by change of colour, I tried several positions, the last of which was going up my multi-coloured curtains, and the result was that he turned a neutral grey – playing safe in other words! Careful drawing needed here with a little watercolour wash and a mapping pen for outline.

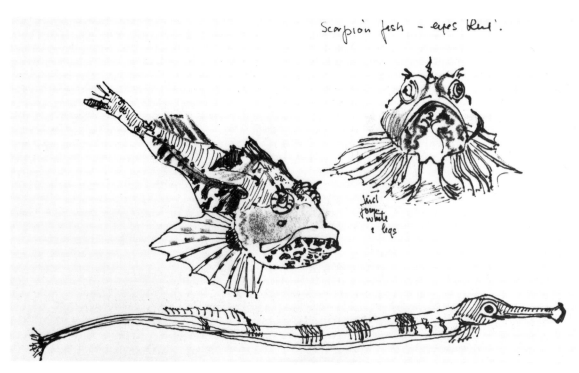

Scorpion fish – eyes blue.

incl. four white & legs

58 Scorpion and pipe fish. These were pen studies made in an aquarium in a very bad light! Rather cold and uncomfortable, but fascinating. The scorpion fish is quite extraordinary, and you will see my note that he had blue eyes and that the first four fin marks and legs were plain white. I added a touch of brownish oil pastel on one study.

59 Sea horses. Another aquarium job. These little creatures kept moving, although slowly. I was intrigued by the baby hanging on to Mum's tail.

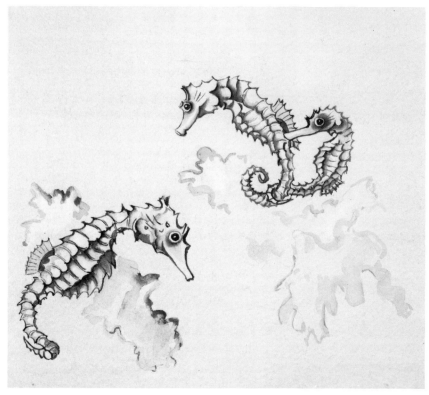

60

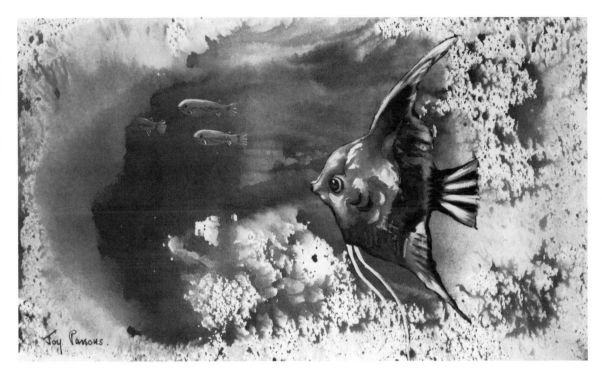

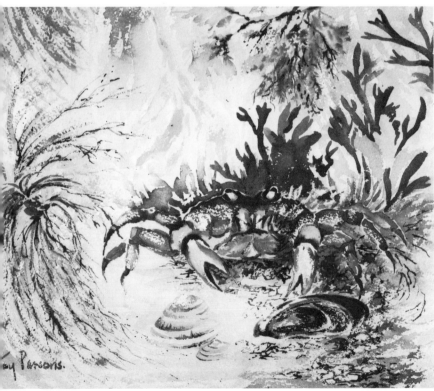

60 This was painted on an experimental monoprint background with gouache paint. The background went on first, and the fish matured from a sketch I did when I saw him in a restaurant aquarium: A rather more limited existence than in their natural environment of the Great Australian Barrier Reef!

61 This was rather an experiment in a way, as I used wax in this painting and also added coloured ink using a straw to draw with. I had used, on purpose, Arches rough paper. This and the wax gave the exact effect I needed on Cuthbert's shell.

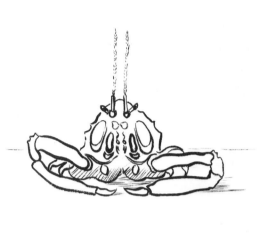

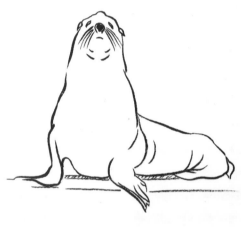

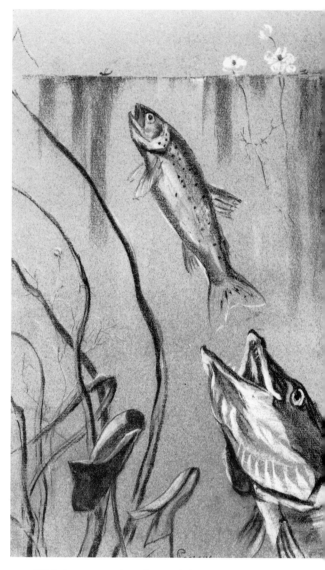

62 These two characters were done with a brush pen. The masked crab, as I mentioned, in his 'Lotus' position, and the sea lion – don't we all know people who look like this!

63 Pike and trout. This is a pastel done on grey paper. Both fish were, of course, dead. Not quite knowing how to get the angle of the trout, I hung him up to the ceiling in our large bay window and worked away, lost to the world. I suddenly realised I had a wondering crowd of passers-by standing on the bridge watching! Painters rarely realise how potty they must appear to non-painters!

64 (*opposite*)
Sometimes we walk miles looking for subjects and this one I found right under my feet! A parasitic wasp paralysing and carrying off a caterpillar (very likely a broom moth to which they are partial). I had no idea what I was drawing at the time, of course; half the fun is coming home and identifying your work (if recognisable)!

Joy Parsons.

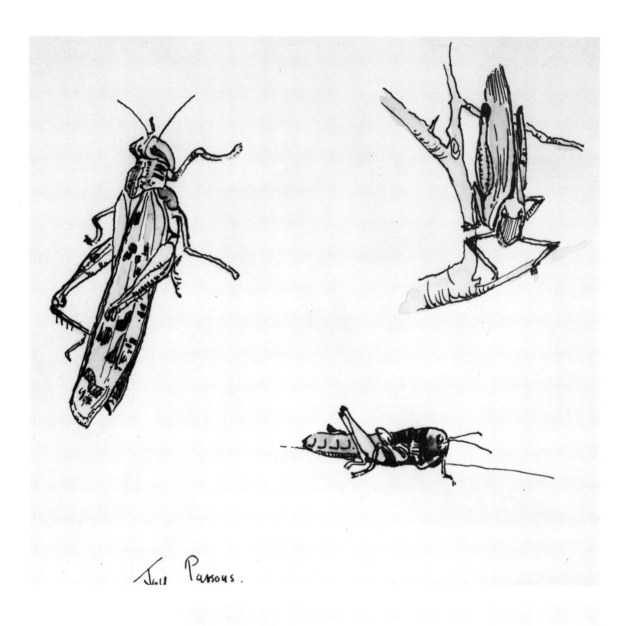

Jill Parsons.

65a Now, you will say, how in the world did I come by a locust? Well, they were kept in the back regions of a bird garden to feed to the bee-eaters! One has lost a leg, I think.

65b A beetle, found in the New Forest.

Nests

Nests make interesting subjects – with or without occupants. It is remarkable how, just as progress affects the human world of construction, building materials have also changed in the bird world! Take a blackbird, for instance: when its nest becomes available for close observation, one of the chief ingredients, around here anyway, seems to be bits of plastic, garden nylon netting and the like. In fact, it is often a bit of trailing plastic that will give away the location of the nest. The most inadequate-looking structures are the collar doves' residences – just a few hastily laid twigs which one can see right through when standing underneath. In our pine tree at dawn with a pearly sky as a background, they make a lovely silhouette. A watercolour mixture of Light Red and a touch of Cobalt Blue will give you the overall colouring.

The beautiful and unique River Test provided me with details of a moorhen's nest. I spent a long and rather uncomfortable time lying prone across a wooden bridge over the river, gazing through an opportune hole in the planking. This paid off with the final result you will see in fig. 66.

A long-tailed tit's nest which we found in a bramble bush close to another river proved to be a work of art indeed. The fascinating lichen and mosses seemed to be the main building materials here, tied together with spiders' webs (fig. 67).

One year we had a goldfinch's nest in our laurel tree which meant that with a pair of binoculars I was able to observe the daily activities quite closely (fig. 68). The kingfisher's nest in the bank of the river has got as far as a drawing (fig. 69), complete with my note that there was heather above, and is now waiting to be made into a picture (given time and energy of which there never seems to be enough).

In a hedgerow one day I found a wasps' nest and was very excited about its shape and structure. The inhabitants went about their business as usual whilst I sketched and even allowed me to break off a morsel of their home to examine; it was just like lace made out of dead leaves in colouring and form (fig. 70). Across the road from this I found a trapdoor spider's nest and spent an enjoyable few minutes knocking on his door and watching him appear to claim his victim!

We are so used to seeing hedgerows dashing past us in the car, that we rarely stop to look closely at them. And yet one often will have to look no further for subject matter; if we would just sit down quietly amidst natural surroundings, we would find so much inspiration within a yard or two. Why, even a falling leaf can be a poem in itself.

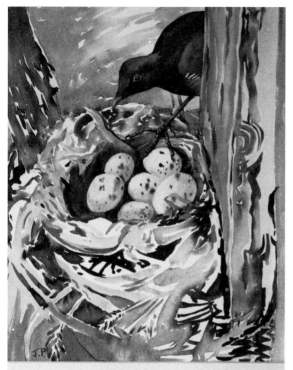

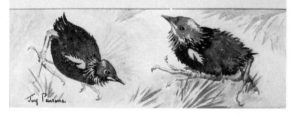

66 (*above*) A moorhen's nest. This is quite a rare sight, so although I was in an acutely uncomfortable position, I felt obliged to persevere!

67 (*left*) Long-tailed tit's nest in a bramble bush.

68 (*opposite*) Goldfinches in laurel tree. This was an enjoyable exercise. I got various sketches dotted about in my book and finally produced them all on one sheet. I did most of this through binoculars and couldn't get more detail.

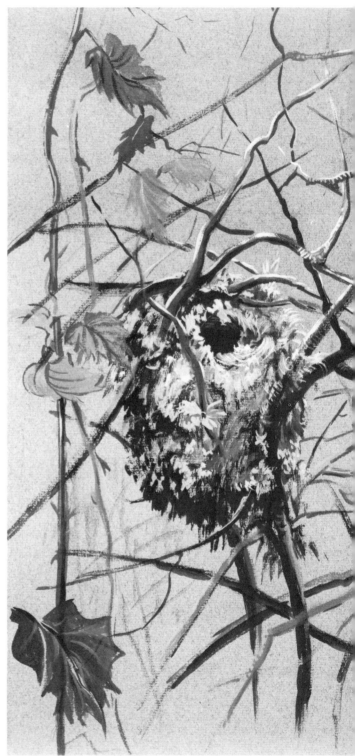

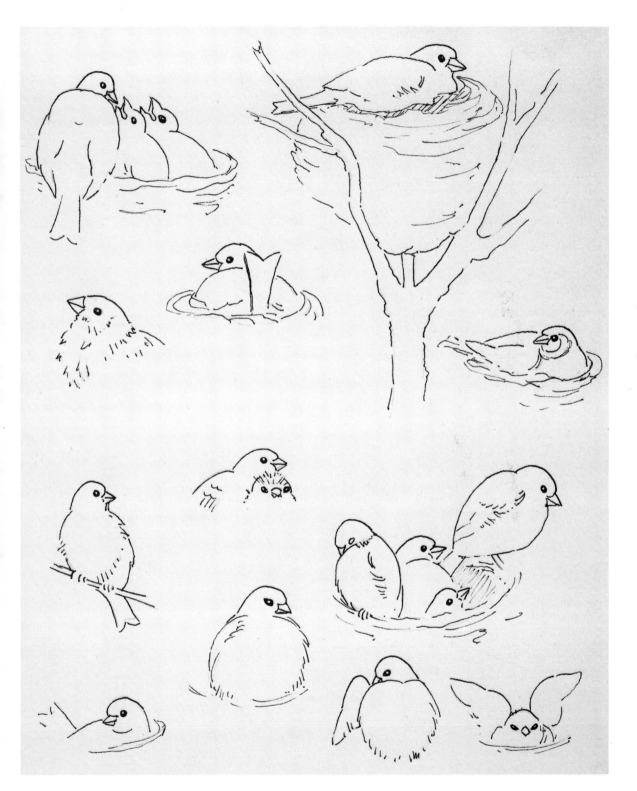

69 This is a sketch of a kingfisher's nest entrance with drawing and notes of the surroundings, all ready to be transformed into a painting! I have, in my Library, the study of the kingfisher and so can put the two together (I hope) sometime!

70 A light pen drawing of a wasps' nest; it is made of such lacy-looking material and you will see how it is built around the stem of this plant in a hedgerow, with the entrance at the bottom.

Hedge To Pare
Then grey?
odd
light red
with

Dawn and Dusk

One of the best ways of getting close to nature is camping. To wake up, look out and see a heron's silhouette close by is really exciting. A few quick notes in a sketchbook, no matter how crude, can be followed up later with such details of bird and surroundings as one can manage, such as my painting done of Tal-y-Bont close to the Reservoir in Wales (*fig. 71*).

Because of our conventionalised lifestyles we tend to miss the wonderful waking world at this hour. Waking one morning recently I saw through the window, and the beautiful autumnal mist, a little collar dove preening, doing her morning toilet, against a background of decorative leaves – just simple shapes. I crept out in my dressing gown down to the silent river. Clouds of swirling mist half hid the group of mallards and the little grebe in apparent attendance. I smelt the uplifting perfume of a late rose on my neighbour's wall and settled, bewitched, to make a note of a dew-covered spider's web. I shook it, but the owner did not appear. This, of course, will be a gouache work on tinted paper. Maybe another morning I'll catch the spider at home!

Nothing should be too small for our attention; it is *all* drawing practice. At the same time, I would stress again the importance of collecting and building up a reference library of 'bits and pieces' which you can use at a later date, if necessary, to concoct a new painting or composition. You will find as time goes on that you will gain experience as to what you need to collect, what you will need to fill in the missing pieces of, perhaps, bird, creature or flower (i.e. what the beak of a young bird is really like, which way the hedgehog's spines grow according to the different parts of his body, which petals or blooms are in shadow, what colour is the eye of some creature, and so on).

The dusk is also a very exciting time at which to stay silently somewhere – watching. When I have finished this page I am going out to the pond in the garden with a torch to see how many frogs we have spawning this year!

71 (*opposite, above*) The Tal-y-Bont Reservoir in Wales. Here we camped and I was bewitched by the fact that there was a drought and the water level was so low that all these intriguing old stakes were above water. I settled down to do this and suddenly into my line of vision swam the great crested grebe – a bonus indeed. Hastily I grabbed a sketchbook and got a quick drawing of him and then later resumed my painting incorporating the bird where I wanted him. Back now to monochrome, Brown Madder and a wash over the entire sheet with the exception of the tree stumps which were carefully preserved. I washed out the shape of the bird and his reflection and a few water marks. I then proceeded, with a fine pen, to fill in the background rocks and pebbles (after adding the deeper bits of colour). Then changing to a thicker pen, I continued with the main tree stump and foreground, thereby obtaining more recession than if I used one pen all through

72 Just a simple silhouette of little collar doves, preening themselves on a misty morning – simple shapes and four tones.

73 This was a subject that I saw from my bed whilst on a sketching party week. It was a beautiful copper beech and each morning the rooks would fill it up, so before breakfast every day that week I did a little brush drawing with a No. 6 brush and Indian Ink. It was worked on a plain pink wash of watercolour and eventually made a good screen print. The rooks were added when I got home from sketchbook drawings.

1 *A pure watercolour and a classic arrangement of a rose in a glass container. The rose is New Dawn.*

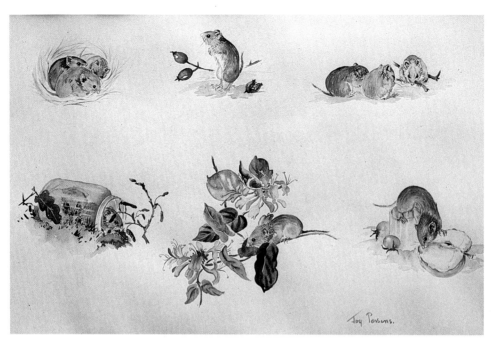

2 *This shows my voles indulging in their many occupations whilst resident in my sitting room! Needless to say, many drawings were done to produce this sheet finally. Their little hands were so expressive, and every new item of food or foliage put into the glass house was an immediate source of interest and activity.* (Photograph courtesy Harold Morris, in the collection of Mr and Mrs J. A. Parsons.)

3 *Young pike. This is a pure watercolour, painted as best I could from a small aquarium on the sitting-room table. I managed to get him well lit. When I see their enormous orange eyes glowing I'm always glad I'm not a minnow!* (Photograph, in the collection of Mr and Mrs A. M. Parsons.)

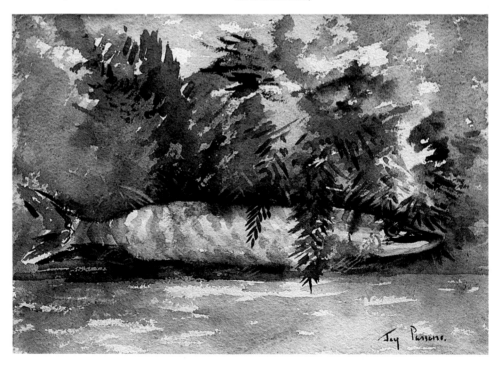

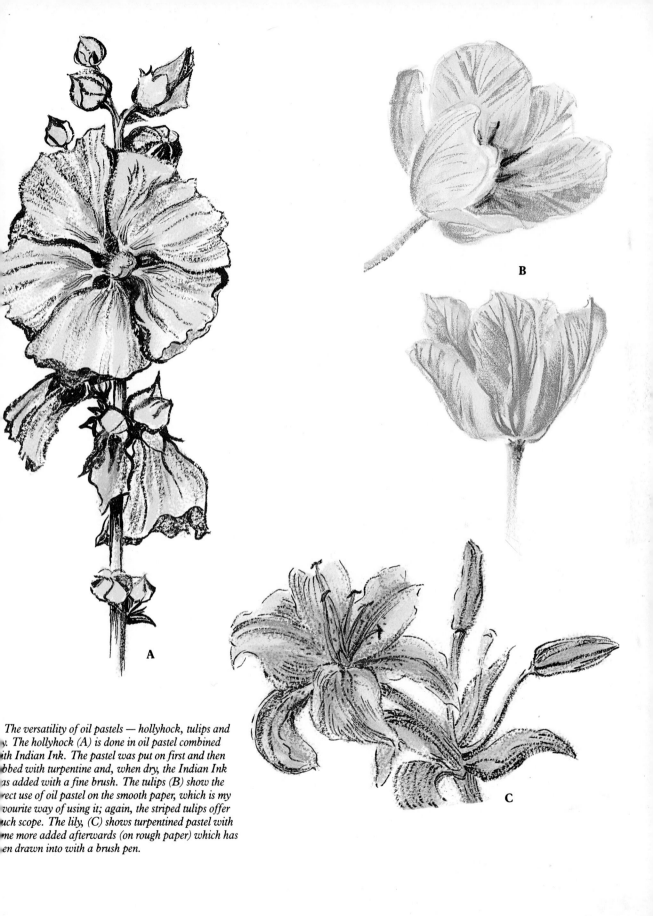

The versatility of oil pastels — hollyhock, tulips and y. The hollyhock (A) is done in oil pastel combined ith Indian Ink. The pastel was put on first and then bbed with turpentine and, when dry, the Indian Ink as added with a fine brush. The tulips (B) show the rect use of oil pastel on the smooth paper, which is my vourite way of using it; again, the striped tulips offer uch scope. The lily, (C) shows turpentined pastel with me more added afterwards (on rough paper) which has en drawn into with a brush pen.

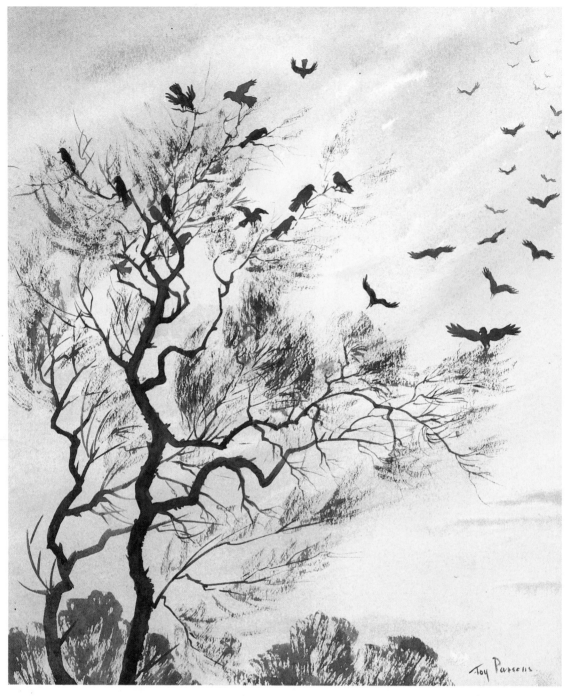

5 *Rooks going to roost. Note the use of the dragged brushwork to indicate winter trees.*

6 *Gouache and tinted paper to depict Henry hedgehog eating. Starting once more with the eye which then makes the creature live, I painted on from there; no pencil, just a few painted guide lines.*

7 *Vole and apple. This was a lucky break in the garden one October afternoon. I managed to get a quick drawing of the vole using gouache paint again, on grey paper.*

8 *Two young Thrushes from our garden nests, painted with gouache on a maize-coloured paper which seemed to be the predominating colour.*

9 *Common frog and common toad; these are the two characters who came down from Warwickshire in a Cornflake box.*

10 *A friend found this young bird on her doorstep one morning. He was dazed but apparently uninjured, so she popped him into a cage and brought him round to me. No time was lost I assure you! Whilst we have kingfishers on the river, the chances of getting one close by like this are slim indeed. He made an* excellent *model and I did two drawings with slight tinting in my sketchbook before he got restless. He seemed to have recovered from whatever had incapacitated him, so we released him. It will always remain a mystery. This tree trunk and the view of the River Avon beyond was painted in my neighbour's garden and, using Ingres paper and gouache paint, I amalgamated bird and scenery.*

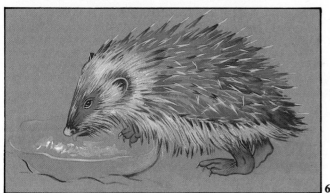

6

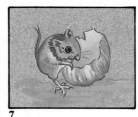

7

8

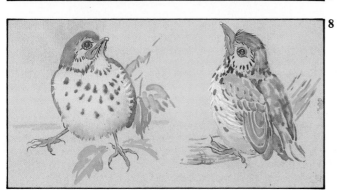

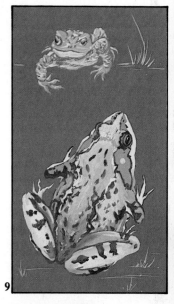

9

10

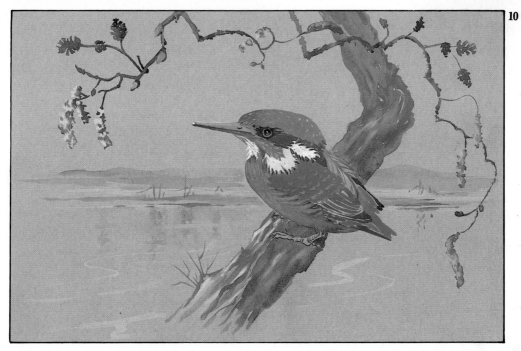

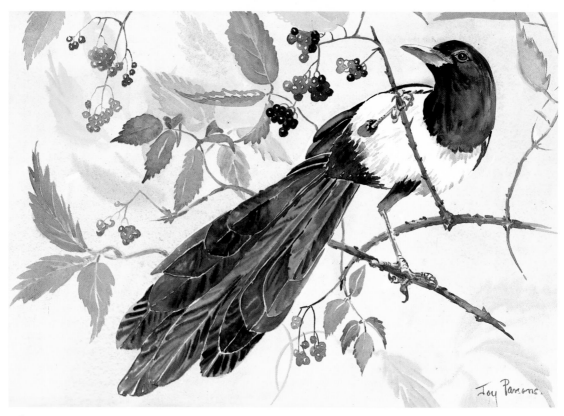

11 *The idea for this painting arose when I saw a magpie in an elderberry tree alongside a Cumbrian railway station! This, in the way these things happen, set me thinking and, realising that I had a close-up detail of a magpie at home which I had acquired in the local zoo, I took some berries home and worked the painting out.*

12 *Flowers and landscape at Evercreech. This was a demonstration painting. The initial sketch from which it was painted is on p. 74. The sky wash went on first, then the horizon and last of all, the flowers.*

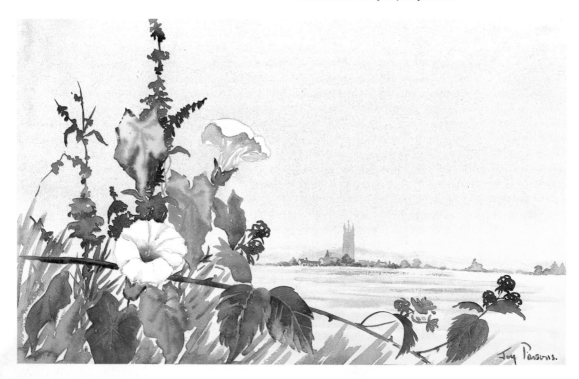

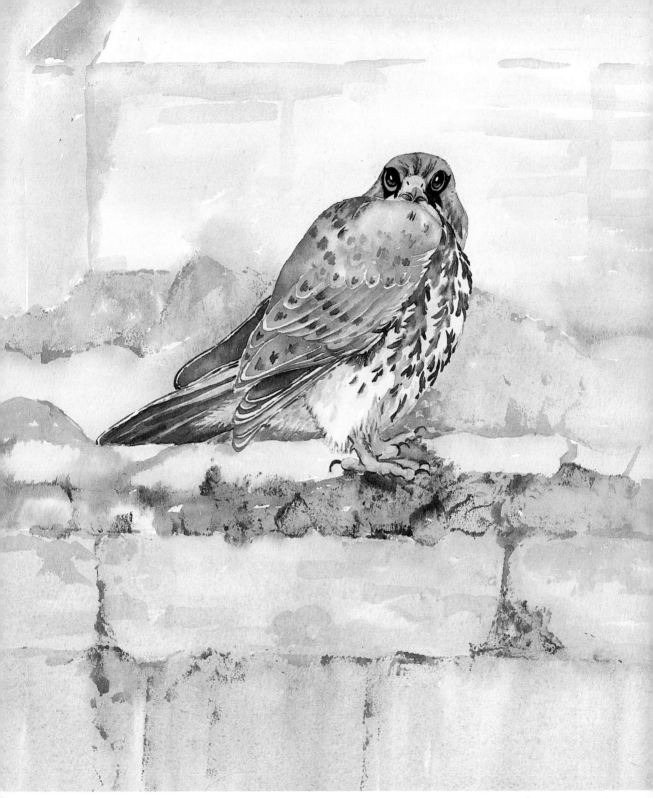

13 *This really was a lucky break. Wandering around our local priory one morning, armed with my sketchbook, I chanced to look upwards and there was one of the kestrel family we knew were breeding there somewhere. She had evidently just left the nest and appeared to be frozen onto the ledge above me. A long staring session took place and I got a really close-up drawing of her in several positions which were eventually turned into paintings, one of which you see here. Pure watercolour used; the eye was painted in first as usual.*

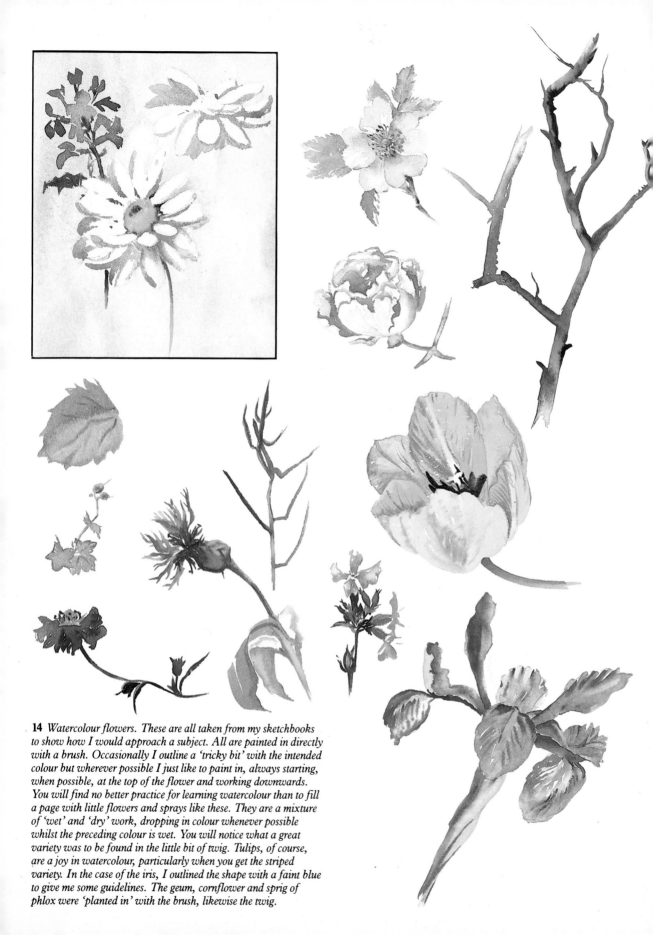

14 *Watercolour flowers. These are all taken from my sketchbooks to show how I would approach a subject. All are painted in directly with a brush. Occasionally I outline a 'tricky bit' with the intended colour but wherever possible I just like to paint in, always starting, when possible, at the top of the flower and working downwards. You will find no better practice for learning watercolour than to fill a page with little flowers and sprays like these. They are a mixture of 'wet' and 'dry' work, dropping in colour whenever possible whilst the preceding colour is wet. You will notice what a great variety was to be found in the little bit of twig. Tulips, of course, are a joy in watercolour, particularly when you get the striped variety. In the case of the iris, I outlined the shape with a faint blue to give me some guidelines. The geum, cornflower and sprig of phlox were 'planted in' with the brush, likewise the twig.*

Flower Painting

Despite changing fashions, flower painting seems always to retain its popularity. When one considers that the first known flower paintings appeared on the walls of Egyptian tombs some 5000 years ago, and one realises all the various trends and 'isms' that have come and gone, one is tempted to ask why? A modern painter friend of mine put his finger on the answer not so long ago. He said flower painting can never become old-fashioned because it is part of nature. This is very true because, even in this noise-racked world, flowers remain very much part of life for a great many people. They provide inexplicable refreshment for the sick and the weary, they adorn our houses and window boxes, they provide motifs for our dress and curtain materials and supply never-ending problems and delights for our eyes and our paintbrushes! Also, at this moment in time when man seems bent on destroying himself, the delicacy and serenity of the flower world can be a very real antidote to our strains and stresses. Matisse said:

What I dream of is an art of balance, purity and serenity, devoid of troubling or depressing subject matter, an art which might be for every mental worker, be he business man or writer, like an appeasing influence, like a mental soother, something like a good *armchair* in which to rest from fatigue. (*Matisse : Colour Library of Art*, Hamlyn Publishing Group, p. 31)

The rapport Matisse had with his surrounding flowers and plants, which I mentioned earlier, is particularly interesting now that scientists have begun to think that flowers are living things and can feel and talk! There is a book on the subject entitled *The Secret Life of the Plants* (Christopher Tomkins and Christopher Bird, Allen Lane, 1974). This claims that plants have the capacity to communicate and perceive; that they appreciate attention; that they will wilt or fade at violence, and that they will react well to classical music and cringe and die from 'rock'! I have myself listened to their little 'song' (or whatever you wish to call it) which can be heard when wired up to a Bio Activity Translator and which is fascinating. And all the plants have different 'songs' or reactions. We all know the difference between a clever or interesting piece of work that makes a fine gallery picture and something that we would choose to live with. Paintings of flowers whether they are delicate or colourful always seem inherently soothing – Matisse's armchair.

It must be realised at the start that if clarity and freshness are desired, then one must be prepared to make the extra effort to keep washing the brush and re-dipping into this and that colour in order to 'drop in' or strengthen as one works down a spray or a bloom. Notice here that I say 'works down' a spray or a bloom, as I find people tend to succumb to the temptation to mix up one

74 A combination of flowers and landscape at Evercreeth. This is the original sketch from which colour plate 12 was painted as a demonstration painting. Here is a leaf out of my faithful little sketchbook and you will see that, although small (original size $5\frac{1}{4} \times 4$ in.), I have included considerable detail which I knew I would need at a later date for enlargement.

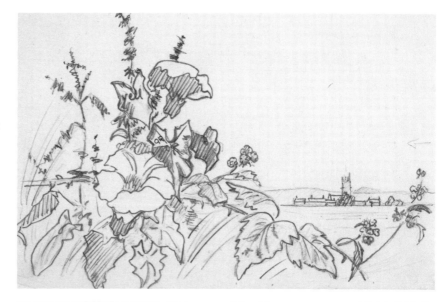

75 Just a careful 'documentary' drawing of some flowers painted on a wet day on holiday in Majorca.

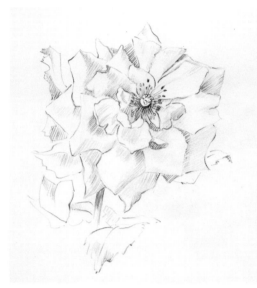

76 A pencil sketch of my pet rose 'Ophelia'. She blooms in a cold greenhouse and this year has been in flower from April until Christmas Day, despite all setbacks. I commenced with the centre of the flower and worked outwards.

77 White tree paeony. Here was an exciting subject and I thought pastel would be the answer. I used black for the leafwork instead of green and worked out the pattern. You will see that the grey Ingres paper served for the shadow pieces of the flower, and the shape of the lighter bits was added with the pastel strokes which, in some cases, allowed the original paper to show through giving an additional tonal effect. This lovely flower is one of my treasures and gives me about four blooms every year, so I'm furious if I happen to be away just when it comes into bloom!

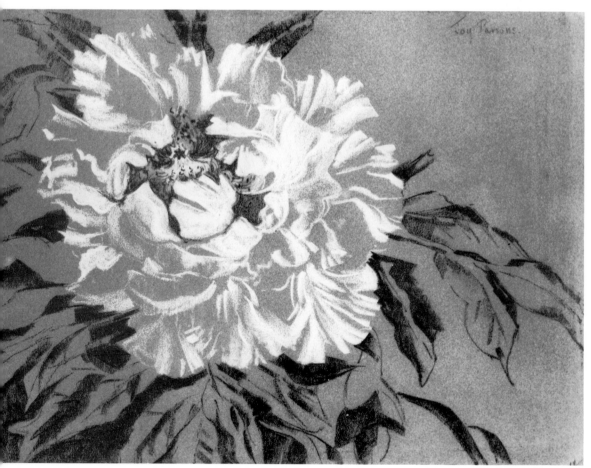

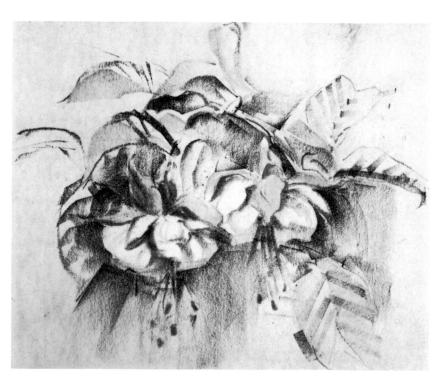

78 Back, now to oil pastel for the fuschia study; subtle or crisp results are possible on smooth paper.

colour and let it suffice for all blooms or buds on a spray, hopping about the sheet of paper and leaving little coloured 'postage stamps' all over it! Each spray will then have to be connected and the work will have a flat and uninteresting appearance, lacking sparkle and life. So, try to work from the top down, bit by bit, varying the colour and tone as you go, doing your best to get it right first time. Final touches can be added at the end. Also, don't forget to change the water in your container as you progress – it is very easy to get carried away with the excitement of painting and then find you are trying to wash your brush in a 'Bisto'-like mixture.

Composition: formal arrangements or growing flowers

If you are painting a 'classic' group of flowers in a pot or container, do try to forget the container as much as possible – it is the flowers in which we are interested, but so often the pot dominates the picture. Also, remember a little recession on these occasions. People tend to get so engrossed that they give the whole bunch the same amount of loving care and attention; try to make one or two blooms say much more than the rest. Try to paint flowers life-size when possible. There is a strong tendency to dwarf groups, usually to get them on to a small sheet of paper. It is not necessary to get the whole lot on, you know! Place your focal point (flower or flowers) where you want it on your sheet and then work out from that. Do not be afraid to let some of the outer blooms or stems run right *off* the paper, as long as you do not let them stop exactly on the edge of the paper where they would then 'sit on the mount' uncomfortably.

76

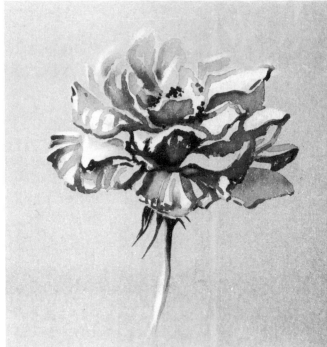

Composing a picture worries some people while others take it in their stride. It is a sensitivity towards balance and goes back again to the idea of the focal point; the satisfactory arrangement of the subject within the picture plane (i.e. the paper or canvas). It can be a very weak point amongst beginners when they come to flower painting. When sitting down to do a formal group in a pot or container, the latter is invariably placed too close to the bottom of the paper. Even when working a large sheet, a half imperial, say, people will still do this and will probably forget to do the group life-size so that they will be left with an oasis of empty background. If you are working with large blooms, use a large sheet. If you do not have one, get your focal point correctly placed and, as I said before, let the rest run off; it will probably look more interesting anyway. One thing I am very keen on is the under-emphasised container, unless it is some intricate design. When working with glass, which I greatly prefer, it is quite possible to soften it off and fade it out. Otherwise, be as suggestive as possible. Sometimes people plant a group of beautifully painted blooms on a sheet and just leave them with no stems or base indicated at all – this I find rather worrying. It is very important to arrange the flowers in an interesting way in the first place. So often a bunch is just stuck into a tall vase with all the stems the same length. This is fatal: all the interest will be on the upper half of the paper or canvas and there will be a hole in the middle around the neck of the container. It does not matter how excellent the technique employed, the onlooker's eye will not be satisfied.

Try to keep the smaller, lighter or paler blooms at the top and to the

79 and **80** Three methods of painting roses. In **79a** I put a wash right over the Bockingford paper and then, before it was dry, I lifted off the shape of the main light petals, leaving a sort of skeleton behind! When this was quite dry I then very gingerly started to build up the tones of the flower (**79b**), adding the very darkest touches right at the end when I could see where and how much emphasis was needed.

77

80a Here I put on the background using Paynes Grey, and drew the shape of the flower at the same time, leaving pure white paper which was later built up by adding the petals and the centre, etc.

80b Here I wet the paper in the shape of the rose and with its palest colour, waited a moment and then put in the more impressionistic strokes of the petals, thereby getting quite a different effect. Here are three methods – take your choice!

81 (*opposite*) Demonstrating painting. Here you will see the same principle carried out as in the rose paintings. The only thing actually drawn beforehand was the shape of the large white daisy which I wished to *preserve*; the rest was added directly with the brush, the central daisy and the container being the last things to be dealt with. A little colour was lifted off in places. Here I used Brown Madder, which is not really brown at all but a rich, pinkish colour. I let a little water trickle down the page before putting in some of the background colour, to make it a little varied.

outside and the larger and brighter ones to the centre of the group, with one almost certainly breaking over the edge of the container, or a spray of wandering leaves. Here we are not making coloured photographs; remember, we are translating what we see into a picture.

Don't be tempted into copying transparencies of flowers unless you really have no access to real flowers. I would far rather have one single green leaf that has been painted from a pot plant where you have had to make your own decisions as to which green, whether you wipe out or delineate the veins etc., than a copy of someone else's work. Constable once wrote: 'I would rather possess a freehold though but a cottage than live in a palace belonging to another.' (*Memoirs of the life of John Constable*, C. R. Leslie, R.A., Phaidon Press, p. 280). This, I think, is what he meant.

Watercolours for flower painting

Here I would like to mention a few special watercolours which I do think you need for flower painting: Permanent Rose is a must; it has rather replaced Rose Madder and is a beautiful colour. Cadmium Lemon or Lemon Yellow, Indian Yellow, Cadmium Orange and Cerulean Blue and, of course, Viridian, rarely to be used pure but mainly for mixtures. Another must is Scarlet Lake, and a ready mixed mauve is an advantage though one can get quite a nice one by mixing Permanent Rose and Cobalt Blue. Don't forget the Brown Madder! Alizarin Crimson you probably have anyway.

Backgrounds

Backgrounds are usually a vexed subject for beginners, mainly because they don't know how to deal with them technically, and often a nice piece of work remains on plain white paper because the owner did not dare to go further! Go back to the initial plan – what *sort* of background do you want? Variegated or flat, light or dark, harmonious or contrasting? It is always worth remembering that a contrasting colour is an effective and safe bet (e.g. yellow daffodils with a blue or blue-grey background). Try mauve flowers with a touch of Lemon Yellow behind them, either flat or varied with a little grey run in here and there, and try to arrange as you go that the most yellow area comes directly behind the mauve flowers. A soft grey is also pleasant.

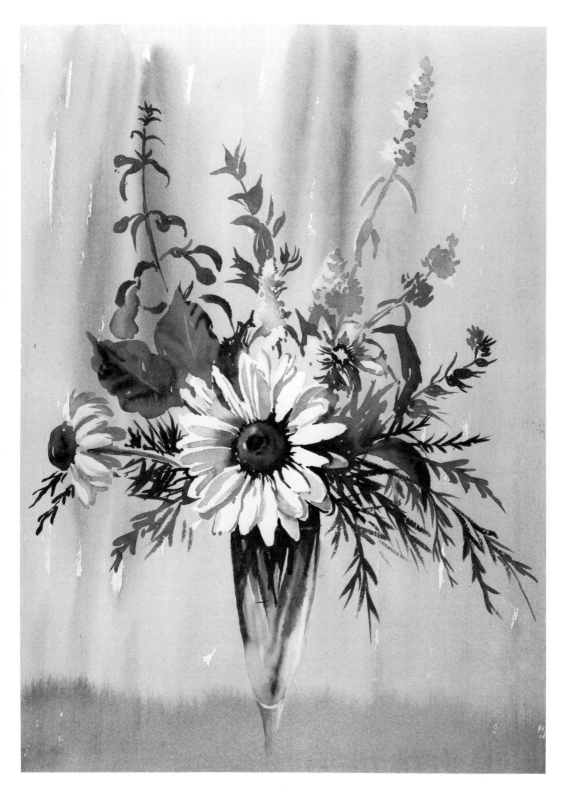

82 An example of my usual approach: preserving the white paper for pure watercolour, lifting out a little, then adding a little and, finally, building up.

Applying a wash

I use different approaches to this question according to the subject and the mood that I am in. In the majority of cases I prefer delicate and suggestive backgrounds and the following is my usual method of attack (*figs. 80–85*). I first draw in my main flower or focal point lightly with a brush (No. 5 or 6) and blue paint only. If this focal point should be a pure white flower or even a light or bright one, then it will remain as untouched paper.

At this stage, having decided upon the colour scheme, mix up an enormous wash, or if it is to be varied, two washes, then flood on the paint with a big brush, with the exception of the drawn flowers or leaves. Here, of course, comes the argument for the use of masking fluid to preserve the white paper but I have nearly always stuck to the direct approach and worked my way around the drawn sections.

Always mix more colour than you expect to need – it is fatal to run out in the middle. Pick up excess colour at the bottom of the sheet with a semi-dry brush otherwise it will seep back and make a horrid mark. If you are doing a classic group in a container and a shelf or table line is required, you can pause at this level, wait a minute and then proceed down with perhaps another colour. This horizontal suggestion should always be minimised to be attractive I think; it is the cluster of flowers which are the real interest.

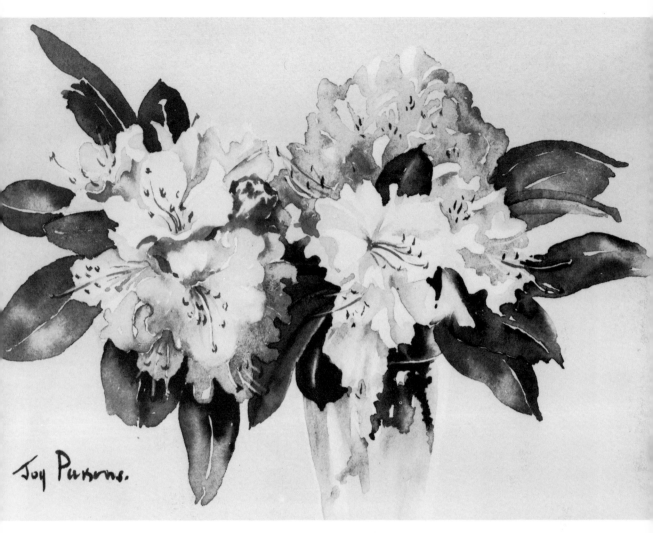

83 These rhododendrons were painted in with the brush and this
painting is the only one in this book to be done by nightlight in my studio.
I followed my usual formula: background first, preserving the white paper
for the lightest, wiping off a little here and there and varying the colour
from liquid to crisp touches. The leaves in this case are very simply treated,
as you will see. It is a pure watercolour.

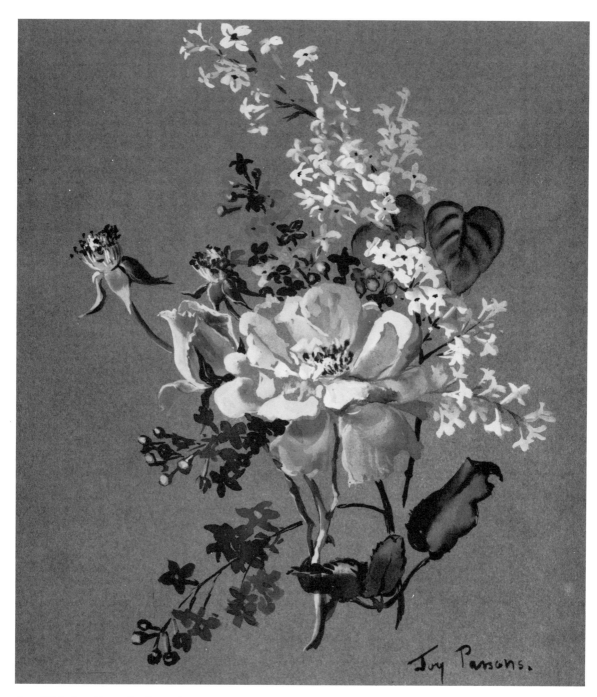

84 This is a Gouache for a change, and the reverse technique takes place; all highlights and lighter portions are applied with thicker colour to which white has been added, instead of leaving the pure white paper as in pure watercolour. I started at the top of the group and worked downwards, and indicated the centre of the rose with a little Lemon Yellow to 'get my bearings'. This was worked on the inexpensive Art Cover Paper.

Lifting off and dropping in

Now, when all is wet, drop everything except a semi-dry brush with which you are happy and conversant and proceed to 'lift out' any desired shapes. So many flower paintings are ruined by the fact that all the blooms are on the same level and have no recession; some flowers should say much less than the others, surely? This is where a little poetry is needed!

This stage of lifting off, in other words drawing in reverse, must be carried out quickly when all is wet; perhaps a stem here or a leaf there. If painting glass, this should be indicated now. If things have got too dry to take the colour off, it is possible to re-wet and try again when all is *completely* dry, though it is never so successful.

On the other hand, it is possible with practice to wet areas and 'drop in' a little colour behind groups when you have finished or, sometimes, half way through a painting. That which is light and bright should be preserved and whatever is stronger and darker can be painted on top. So, there is a lot of 'sorting out' to be done here, as every bunch or group will be different. It all goes back to you and what you want to say on your piece of paper.

A very dark background is best put on when all the flowers are finished. Damp the paper around the flowers and then, with your board at an angle of 25 degrees, flood on the wash, starting, of course, at the top.

Incidentally, if you are painting flowers in a container, muslin or net curtains can provide an attractive background.

85 Here is a completely different approach: a flat pattern with no variation in tone, forming a decorative design. Done in pastel on sandpaper, I worked from a tiny sketch and used patches of brilliant purple, orange and Cerulean colours, surrounded by a neutral background.

83

Foliage

86 This comes into the experimental range of working. Attracted by these lovely oddments in the New Forest, I arranged then in a sort of pattern, giving me my bright orange bit of fungus where I wanted it for a focal point. I put on the background colour (a delicate yellowish green) and wiped off a bit or two here and there. I then played with masking fluid to preserve certain projecting areas which I considered important. Next I applied the darks – all watercolour, by the way – a mixture of imagination and realism used here. Then, off with the masking fluid and my touches of pure orange were added to make sure of my focal point. Lastly, I played about with a mapping pen and Indian Ink. This was painted on a rather 'grainy' watercolour paper which helped create the effect.

87 (*opposite*) Hurriedly painted on the spur of the moment in order to catch the beautiful variation of colour in these bramble leaves, spindle berry and 'twiggy' oddments brought from the New Forest. All brush work.

Studying colour

How, you may ask me, can we become more aware – how can we improve our latent colour sense and get more excitement? Well, I suggest that you spend a period studying *foliage* as opposed to flowers. It is obvious that most flowers are coloured but in order to search for colours, look at foliage – garden or wild. Go into the forest after the rain; you will be amazed at the way in which some of the leaves and tree trunks have come alive with colour. When the countryside is damp and mysterious the colour vibrations seem to be greatly enhanced: the thorn on the wild rose shoots may show itself to be pure scarlet lake; the young sycamore trees may vary between raw sienna and a rich wine-red. The coniferous trees are my special favourites, with their almost Cornish sea water blue-green, and then consider them when the hordes of tiny cones arise each year, the palest possible lemon colour – a perfect combination. Also search out the wonderful range of wild parsleys and hog weeds with their lacy leaves which so often turn to a wonderful mauve or magenta shade. Toadstools and berries also make fascinating studies of shape and colour.

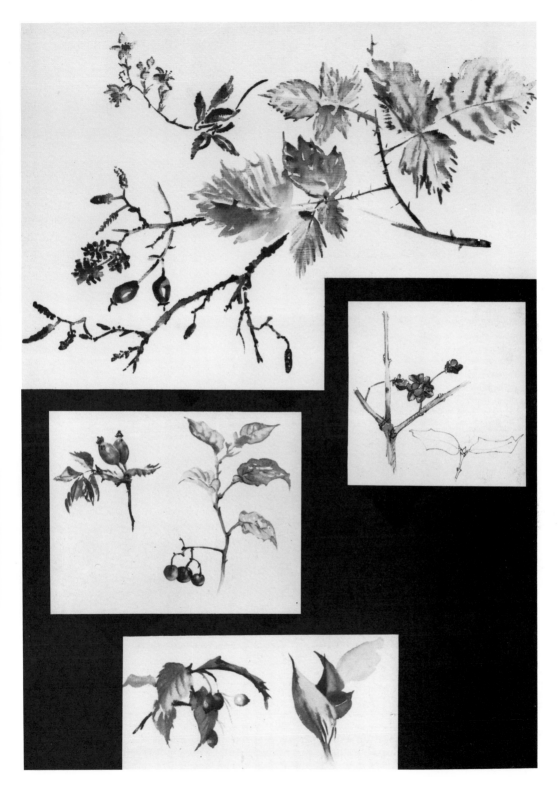

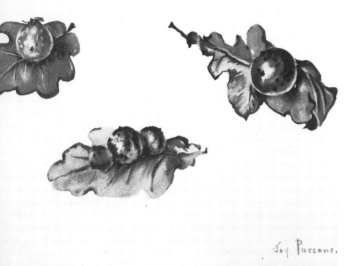

88 (*above*) Oak leaves
with attendant oak
apples again. These gave
me a tremendous scope
for seeing what I could
do with three colours –
French Ultramarine,
Cadmium Red and
Yellow Ochre, plus a
little black. The faintest
tint of Yellow Ochre was
put on first and the other
colours added whilst the
Ochre was wet. (Brush
drawing.)

89 (*above, right*) Black
paper here (Canson) and
gouache for this little
study of New Forest
fungi and oddments, just
picked up and brought
in as they were.

90 (*right*) More
fascinating lichens and
fungi which I brought
home to paint. Gouache
on black paper again,
directly used here; in
colour, of course.

91 A careful pencil drawing of some bryony leaves and berries. I marked
the bottom right-hand leaf with a Y and a B, meaning yellow and brown,
when and if I came to paint it!

86

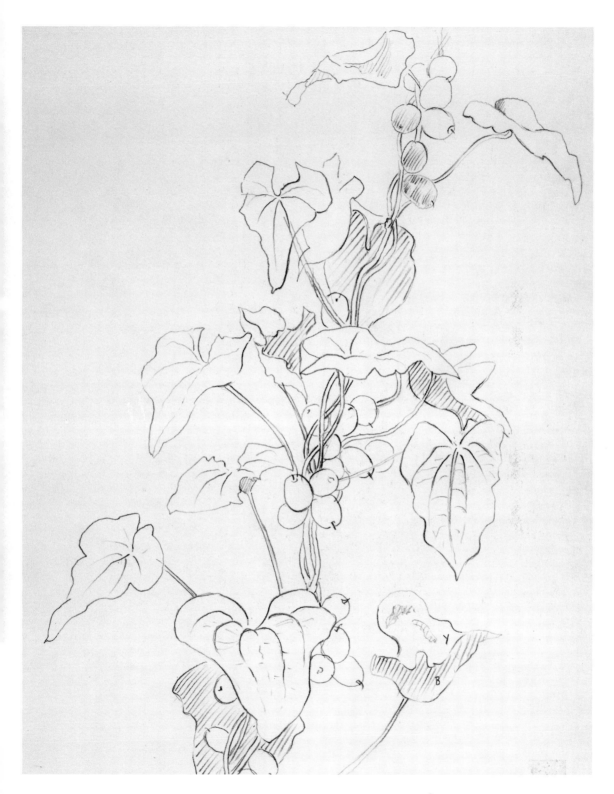

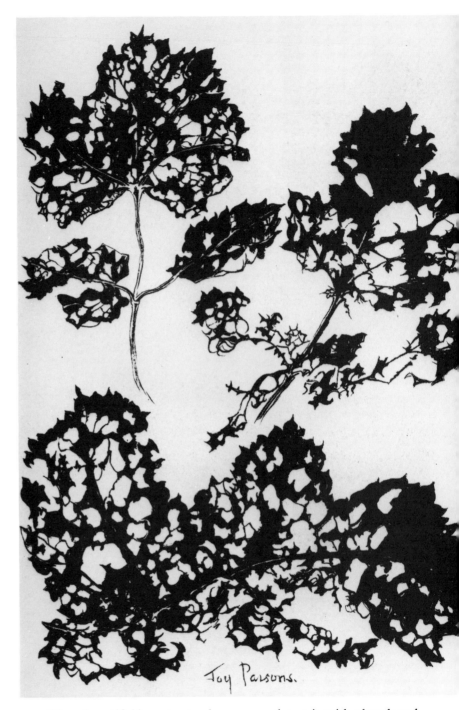

Joy Parsons.

92 These beautiful insect-eaten leaves were drawn in with a brush and Indian Ink. This took considerable time and concentration, but I felt it was well worth the effort. I painted them on top of a Lemon Yellow watercolour background to get the maximum contrast.

88

Studying shape

Quite apart from the colour angle, the study of foliage will make you very shape conscious. Beautiful patterns can be formed merely by using a flat tone. I find more inspiration for a decorative design in foliage than I do amongst flowers; there is so much variety of leaf motifs. There are so many different approaches to every subject depending on the artist's outlook and reactions, i.e. botanical, impressionist and atmospheric, semi-abstract or pure abstract (the latter does not, however, have any counterpart in Nature so does not really fit in here).

Nature is all contrast: busy surfaces as opposed to quiet and unruffled ones, light and shade, growth and decay. Decay, really, can be very beautiful; consider the skeleton leaves with their delicate lacework (*figs. 92–94*). I have found many an inspiration on a rubbish heap. (If you're really keen, you will suffer anything!)

93 (*above, right*) Compared to the previous illustration this only took a very short time, being a print-off, and the result is subtle. This is merely a matter of inking up the leaves and printing. Bindweed leaves are amongst the most attractive, I always think.

94 Gouache and tinted paper were used to do brush drawings of these leaves in their various stages. The great detail and tremendous beauty of the lacy skeleton leaf is shown up by this method.

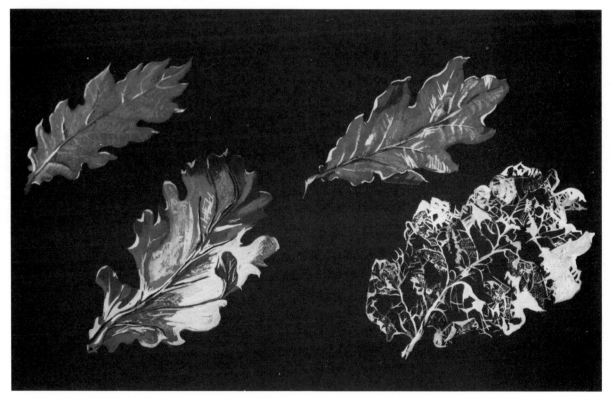

95 Three ways you can produce a leaf in watercolour. (*From left to right*): (**a**) Pale wash allowed to dry and second application flooded on, dark bits being added whilst this was wet but leaving first pale wash for the veins; (**b**) Pale wash again being allowed to dry. Second application used crisply and manipulated as desired; (**c**) Medium wash applied and veins washed out whilst wet. When dry, dragged brush technique used to convey texture. You can, of course, also paint a leaf and not bother about the veining at all – just an impression – take your choice!

Watercolours for foliage

Usually a beginner will suffer from 'Green Fever', i.e. covering his canvas with a bright, ready-mixed green out of his paintbox and, whilst a little brilliant colour on these lines can make a picture, it will need many other variations around it to give it beauty. So here I suggest that for mixing soft grey-greens you can use Cobalt Blue/Yellow Ochre or, slightly stronger, French Ultramarine and Yellow Ochre or Raw Sienna. For spring greens you can use Cerulean Blue and Cadmium Lemon or Windsor Blue and Cadmium Lemon. These give you the sparkling type of green. For strong deep greens use Viridian and Black or Hookers and Black which is similar but stronger. Then there is Viridian and Raw Umber or Cadmium Lemon and Black; a very rich, strong green of which I am rather fond is made with Windsor Blue and Indian Yellow. Try them all out. There is also Viridian and Burnt Sienna. In order to darken a green, add a little red.

Now greys. The importance of knowing how to mix a grey cannot be overstated. I will give you a list to start you off, but there are many more for you to explore: Permanent Rose or Alizarin Crimson with Viridian is a lovely grey for flower work; Cobalt Blue and Light Red is a good and safe mixture; stronger is French Ultramarine and Cadmium Red, Raw Umber and Cobalt or Vandyke Brown and Cobalt; Payne's Grey and Brown Madder will give you a warm or cool variety of greys from light and delicate to very strong and powerful – experiment!

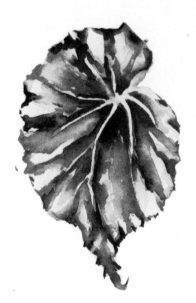
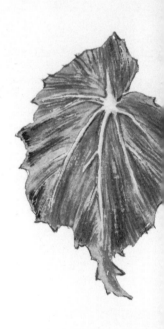

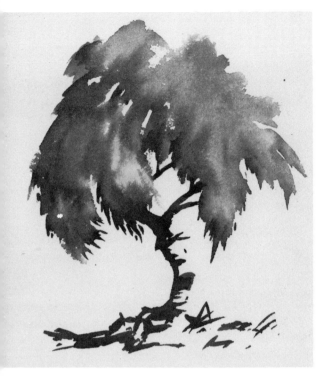

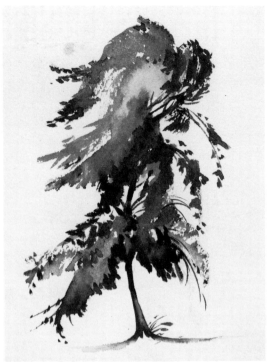

96 These three trees are, as you will see, a mixture of 'wet' and 'dry' painting. Colour has been strengthened by dropping it into the paler wash while the former is wet. A few strong touches have been added when all was dry.

97 A flat wash type of background was used in this painting of the bindweed which was outlined with a fine brush and Indian ink later.

Painting
Episodes

Brandy

The telephone rang. 'Could you,' asked a friend, 'take a golden pheasant egg that is still trying to hatch? Mum's gone off with the other two chicks already out.' (Mum was a silky bantam in this case.) 'It is cracked,' she added, 'and I can hear the little one cheeping.' I had visions of the drawings I could do at close quarters – and so the egg duly arrived: so did bedtime and no headway had been made. There must be some hitch. Carefully avoiding the membrane, I eased away the shell to finish off the already cracked circle, put the egg in a shoebox, carefully protected upon a hot water bottle wrapped in a towel and put the box beside our bed. (I had, of course, made a watercolour of the egg in its initial stages as I had received it.) Usually a non-dreamer I waged long battles during this night with endless mice who never ceased to squeak. In a frenzy I awoke to find 'It' had hatched out and was giving tongue in no uncertain manner. The abandoned shell was at the other end of the box. The hot water bottle was hastily renewed and silence fell again. When the alarm went off, 'It' staggered about on the bed and explored. We were enchanted.

Later that day I went out for a brief spell – silence in the box and all appeared well. On my return there was no sign of 'It'. I hunted and hunted. Finally I spied two legs sticking up and kicking convulsively from a crease in the towel. Dying, I thought, I've roasted it. Seizing a bottle of brandy, I diluted a drop in a teaspoon and pushing 'It's' beak open, thrust it down. A long gulp was taken and then another: one eye opened – we'd won the day. After that I was more careful.

I'm well aware that this is really a book about drawing, painting, tone values and approach, but I feel that nothing is lost by knowing the full history of the subject matter and thereby understanding the problems. So I hope I am forgiven for what might, I suppose, be termed self-indulgence as we work our way along.

It was an unusual situation to say the least. Feeding seemed to come naturally but the trouble was that I was Mum and 'Brandy' (obviously named by now) wasn't even content to nestle in my bosom; his main object was to get into my hair with many endearments on the way! Sometimes he would be content to sleep in my hand, but not for long. The squeak was incessant unless I gave in.

Having been promoted to a largish glass case with food and drink and a cut-off feather dusting mop I hoped things would even out. Not a bit of it; *I* was the one. I was the first thing Brandy had set eyes upon and so was all-important. The feather mop, however, worked well and cut out the necessity of roosting in my hair. This did give me the opportunity of a unique and

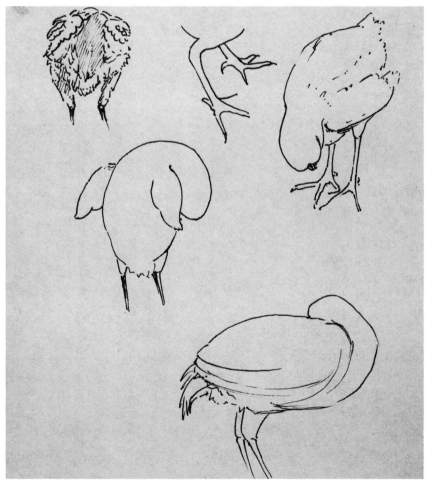

98 Brandy. This shows all his very early stages of development, including a preening session at about two days old which amazed me as *I* hadn't told him how to do it! Instinct on his part and common sense on mine seemed to cope with most difficulties.

99 The pheasant at his 'gawky' stage, preening, pecking and so on – about six weeks old here.

hasty drawing of the little creature both alongside and head-on into the dusting mop, in which position he usually went to sleep for the night. A rapid pencil drawing with a hasty 'tinting' was done on the spot and then turned into a pure watercolour at a later date (*fig. oo*).

Eventually Brandy was given the freedom of our small walled garden and slept in the greenhouse at night, always accompanying us therein for our evening glass of sherry and partaking of the same with apparent relish. Then followed a trying period; he commenced to attack my unfortunate husband whenever he appeared, flying up to his head and pecking hard. This could not continue though it was clear that he was defending my honour and confirmed our belief that in the luck of the draw we had reared a cock bird!

Like ourselves, Brandy is greatly affected by the weather. If the sun is shining he will circle and pirouette on the lawn around us, chattering away and being thoroughly sociable, but if the day is wet and grey he will make a dive for my ankles as soon as I open the cage to let him out for his daily run or into the sitting room for his afternoon snooze. If we come home after a trip out he will give us a welcome in the same way that a dog or a cat would do, but, under normal conditions, I certainly would not recommend pheasants as pets in close quarters as they are generally supposed to be bad-tempered. And, as they can live for well over 20 years, they are something of a long-term commitment.

But, even if I did not realise what I was letting myself in for in the first place, this bird has provided me with many long and fascinating hours with pen, pencil and watercolours. Brandy was a new shape and a challenge, and one which has widened my horizon in more ways than one.

100 This sheet shows the old development of the pheasant's head and hackle feathers as he grew up.

101 (*opposite*) Brandy roosting on his high perch in the run outside my studio. Later we had to reduce the height of his perch as twice he suffered a broken leg – we don't know why except that he might have been frightened off his perch at night perhaps. He was twice put in plaster by our splendid vet and I had him in a pen behind the settee in the sitting room during this period! The tricky bit was having the plaster taken off again after the required period.

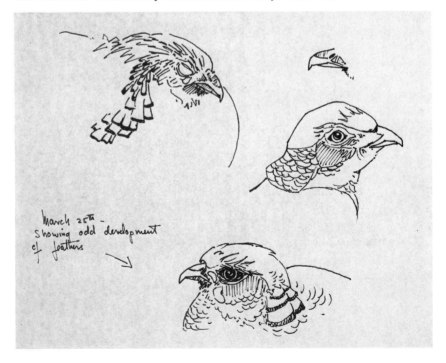

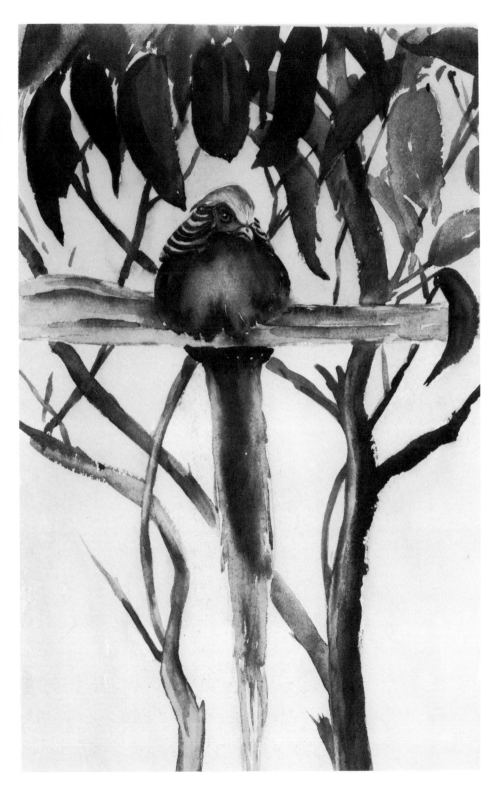

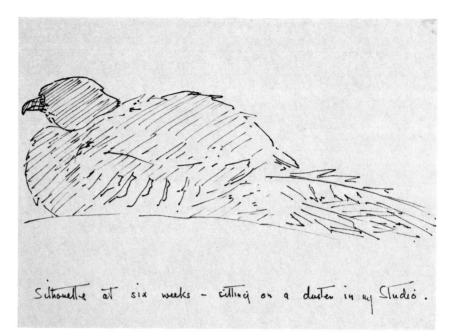

Silhouette at six weeks – sitting on a duster in my Studio.

102 Here in my studio and on the back of my chair in the sitting room. This spot is still his favourite where, with protective covering, he usually has an afternoon siesta!

103 Line drawings trying to catch his different positions whilst preening.

Tufty

My phone rang one day and at the other end was a girl who had worked for some time with the local vet and who had seen me there from time to time. She had, it appeared, been going to work along a busy main road and had spotted on the edge a small black object which turned out to be a duckling, a few days old. She'd taken him home and kept him under an infra-red lamp for five days but couldn't carry on because of her job and immediately thought of me. I should add that I'm known locally as 'the duck woman'!

Of course I'd take it, and 'It' was duly delivered to me; the most attractive thing you can imagine, but with the most *enormous* feet. We had no idea what variety of duck it was so I sought expert advice – a female tufted duckling was the verdict, and rarely seen on our stretch of river except in excessively cold spells. Life was soon revolving around her, established as she was in our large bay window corner with bowl of water and 'playpen' etc. What a chance for drawings! In the evenings she'd settle on my knee happily while we chatted or drank sherry. She loved nibbling my earrings and would, like the baby pheasant, nestle in my hair.

104 This, in pencil, I hope is self-explanatory – Tufty trying to roost in my hair!

105 Experimental monoprint again. The duckling was masked out and the background put in with rollers. The duckling, with his huge feet, was put in afterwards.

She quickly outgrew the window, however, and took up abode on the lawn beside the small garden pond. One particular afternoon I had left her enjoying the sunshine in the walled garden at the back of the house, but when I returned after a brief half hour, no Tufty was to be seen.

Frantically I searched and called, with no result. For two days life was misery. Whilst I knew she would soon be flying it seemed impossible that in a first flight she could clear the 6-foot wall and disappear completely. This, as it turned out, was exactly what she had done. Two days later I looked out of the bay window down on to the gurgling river below where the mallards swim and there was Tufty, fairly laughing up at me and very pleased with herself, but watching me intently. First of all we were delighted, thinking that in a way she would still be with us, but it didn't take long to realise that there, close to the town bridge and all the visitors and children and dogs, she was so tame and fearless of humans that her chance of survival was slim. In a panic I went out and called her. She came into the bank and I grabbed her up to her great indignation. Back home we had a consultation and took a painful, but I think correct, decision. We would take her to the safety of the lovely river Test where many tufted ducks gather in the autumn and which is alive with grebe, moorhens, coot and all manner of other ducks too. No time was lost and upon arrival she was released, all agog with excitement at the sight of the beautiful stretch of water. While she was paddling around we crept away back to the car. Suddenly she took to the air and away she went in an enormous circle – a reconnaissance trip I think. I was reduced to emotional pulp as we drove home; she had been quite our most enchanting episode. The friendly water bailiff for the area kept us in touch with her whereabouts, however. Daily he would look out for her and for about three months she was there. Finally, she disappeared when the flocks came in and presumably found a mate.

Rooks

Amazing! Rooks by the hundred, coming in to roost on a November evening with a glorious pinky sky behind them. *What* a subject! The trouble was I only caught sight of them out of the corner of my eye as I drove home through the New Forest. However, on my return, I grabbed up a piece of Bockingford paper and splashed on the sky wash (still pink and moving as I could see from my window), and then followed with a few distant rooks. Darkness fell and events filled up a week or so before I returned to the spot. I found one tree completely full and quietly settled for the night while, on the other side of the road, birds were still coming in as far as vision went, heading for two elm trees, landing, jostling and shrieking in chaos. Frantically, I whipped out my equipment from the old sketching bag and painted in directly with a full brush the main tree branches against the pre-painted sky. Again I was late and there was little light left, but, using my No. 6 brush I painted in some half dozen birds, silhouettes only, but they had to be convincing, and with the incessant moving they were hard to catch. (Burnt Sienna and French Ultramarine were the colours for this – a good, strong 'dark'.)

Suddenly and unaccountably they rose in a body from all three trees and flew into the distance leaving the branches bare and me thoroughly thwarted. It must, I think, have been a plane coming in to land at the local airport, menacing, no doubt, against the darkening sky. Ah well – there are, I believe, some rooks at home in an old sketchbook – we'll manage!

If you have tried painting living creatures you will by now have realised that the nicest subjects and opportunities will continually present themselves at the most *inconvenient* moments and somehow you must try to make use of them. It is by no means easy but is always worth the try. As Delacroix once said: 'Glory comes dearly.'

Henry Hedgehog

There had been three days of continuous rain and wind in the Sunny South, as it gets called in misguided moments, and we were driving home along the wet road. It was a busy road too, and yet there was little Henry Hedgehog rashly trying to cross it. He was dragging one leg painfully behind him and was barely visible in the falling dusk. Obviously he was very young.

Wrapping Henry up in a striped duster from the car, we took him home and popped him into a plastic bowl to be de-flead with powder before taking up residence in the famous glass aquarium which has now housed so many of my little creatures. On inspection, his leg appeared to be injured but not broken. He ate hugely of bread and milk and was then surrounded by leaves, grass, odds and ends from the garden and the old bit of duster in which he had been wrapped, and left him for the night, whilst I mentally sorted myself out for the next day's drawing. As with all subjects, I gazed for a while and planned; those spikes would be difficult, what colours would I use? What medium? and so on.

The following morning I tempted Henry out of his nest with a piece of cold chicken. The pile heaved and Henry's twitching nose appeared and took a firm hold of the morsel. A tug of war ensued and I frantically drew with a pencil in my sketchbook. It wasn't easy holding a piece of greasy chicken in my left hand and trying to register with my right, but we managed as you will see from the illustrations (*figs. 106–111*). He kept disappearing and I had to grab my moments. When sleepy he seemed happy to nestle in my hand and I soon learned the best way to dodge the spikes when I picked him up. Not having my book handy, all I had was a bit of cardboard packaging from a new pair of tights, so it was put to good use – a pencil drawing to which I later added a bit of watercolour. Next came a monochrome 'quickie'; a brush drawing snatched during one of Henry's brief daytime appearances. It is hit or miss on these occasions, trying to register essential lights and darks, probably between other activities.

Finer details were built up by observation and pencil drawings, piecing them together afterwards, though in the same way with any subject, the more one does it the more familiar one becomes with the basic outlines. I always retain key drawings for future reference in the 'Library' I mention elsewhere, and so have quite a good collection.

Henry's feet were intriguing, but difficult to draw, being so often obscured by the grass and foliage around him. Fig. 108 was a lucky effort showing his open mouth and teeth when he reached up to get some chicken (pencil note and watercolour added later). I was particularly pleased having got this sketch as it was the only time he took up this unusual position.

106 The change of direction of spikes here was all-important. This was done on an odd bit of buff-coloured card I had handy, with pencil, holding Henry in my other hand, and tinted afterwards.

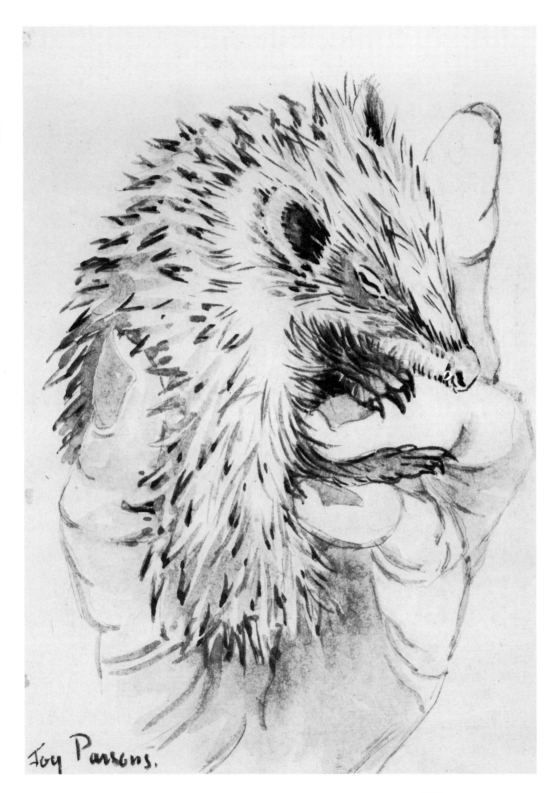

Joy Parsons.

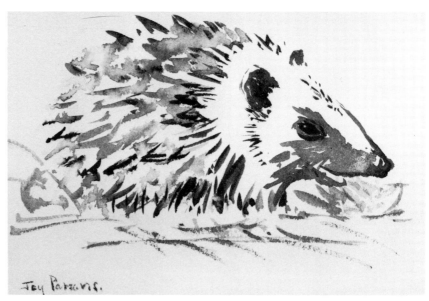

107 A monochrome 'quickie' of Henry Hedgehog. (Brush drawing.)

108 This was a momentary 'snatch' sketch. Just an impression of Henry reaching for a piece of chicken.

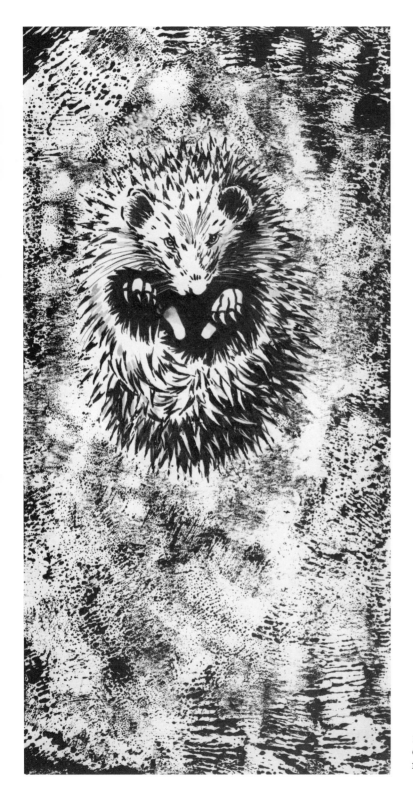

109 He really was an
enchanting creature – in
monoprint again.

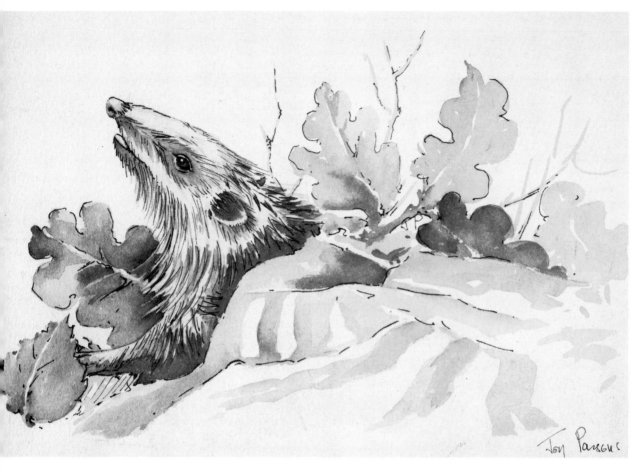

110 Henry Hedgehog emerging from his self-made tent of a bit of pink and white striped sheeting. Watercolour and a touch of mapping pen used here. Several of the hedgehog paintings first appeared in *Leisure Painter*.

111 (*opposite*) My farewell sketch of Henry hastening towards the gorse bush. I did this monochrome in Payne's Grey afterwards from my pencil and charcoal notes of him and his surroundings.

The direct watercolour brush drawing (*fig. 109*) caught him lying on his back and just starting to uncurl his feet. I found I could keep him in this position by giving him a gentle prod and he would proceed to curl up again. Eyes were positioned first, and then I worked out from there. The background was added afterwards.

By now a considerable number of drawings had been done, his leg seemed to have recovered and, as his evening strolls indicated, he was eager to be off. In our little walled garden he would be perfectly safe but would undoubtedly wolf all the little palmate newts and frogs, etc., that I was trying to breed and protect (with fair success). He must go further afield. Hardening my heart, he was taken by car to some woodland about four miles distant and fairly far removed from dogs, humanity and noise. Putting the wee chap down sadly, I wished him luck in the big wide world; after all, it was his sort of world. He looked so small and pathetic as he gave me a backward glance and then headed for the nearby gorse bush. Realising it was my last chance to record, I grabbed my bit of charcoal and sketchbook and made a hasty note of his departure ... just the essentials. The next day I reproduced it in Payne's Grey watercolour, improving or deleting as I thought fit (*fig. 111*).

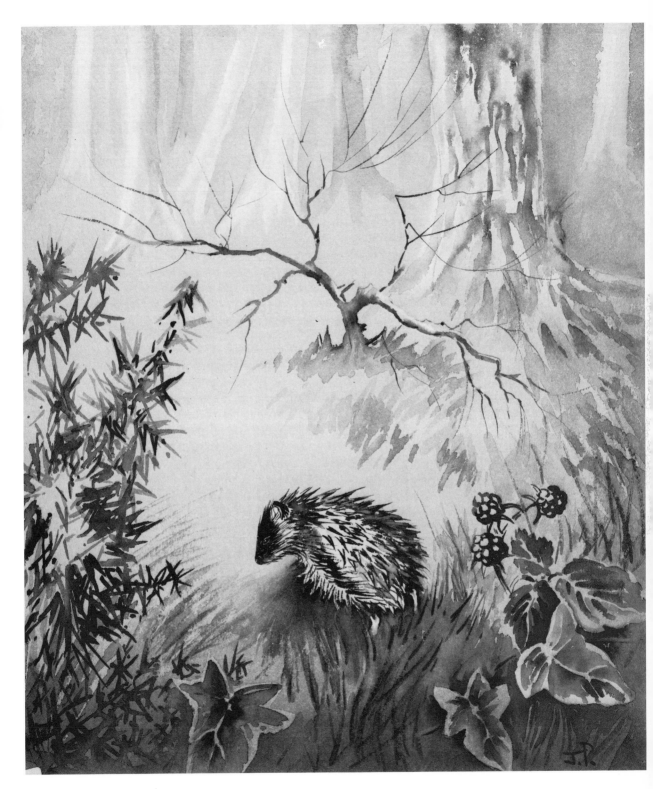

Willy Weasel

Spring tides and southerly gales – together! If you live in Willow Place this means one must be 'on one's toes' – anything can happen. For instance, my studio could be flooded; I might be cut off from my front door by a stretch of water, or neighbours might need to be supplied with the 'essentials' until the tide has fallen again.

The period around the spring tides is always an eventful time of the year. This particular spring we were troubled by rats, and so my husband set up wire traps from time to time to try and keep down these pests, and one day nearing the peak tide, he appeared holding aloft a cage-trap in which sat Willy Weasel. He was very beautiful, but spitting mad. He hissed and fizzed like a firework. I was enchanted – what a chance for a drawing! In came the cage to the studio and all holes or cracks were immediately plugged with bits of rag to prevent escape. As I worked these were promptly tugged out at intervals to study the form. I worked frantically. He was a new and difficult shape and always on the move.

In 48 hours I had worn myself out observing and trying to draw him, so we thought the moment had come to let him go again. Needless to say we 'deported' him by driving him a few miles away and letting him go in a suitable lane with nice hedgerows where he'd no doubt find some of his favourite food items such as voles, mice, frogs, small birds and chickens, though Willy also seems to enjoy carrion, in the form of the butcher's meat on which we fed him.

112 Various positions of the weasel. (Watercolour and pen.)

My struggles with the brush and pencil are shown in fig. 112. Possibly the best effort is the one with the ancient bone beside him which had attracted him in the first place.

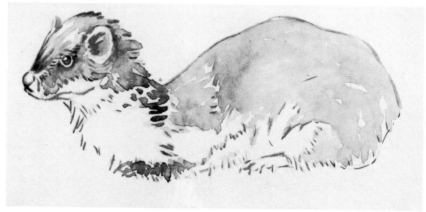

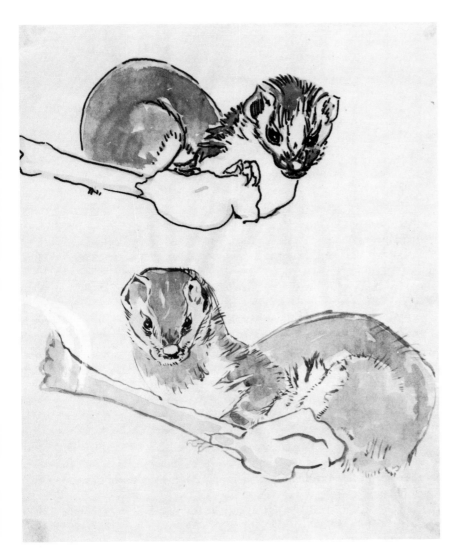

Exmoor Expedition

How exciting to be high on Exmoor after a wet night; sunshine and a blue sky and not a breath of wind. Peace, peace – not a motor in sight, only a wheeling buzzard and, ever on the scrounge, a pair of carrion crows guarding the waste paper bin on a hillock, waiting to pounce should we add our contribution.

Brilliantly coloured whortleberry, low-growing and scrubby, covered large patches and suddenly, amongst layer upon layer of magical, sparkling spiders' webs, heavy with dew, what did I see but one, two, three – no, four gorgeous black and orange, wriggling, hairy caterpillars rapidly making tracks towards bigger and better leaves. This was supposed to be our holiday but, as you will realise, for a painter there exists no holiday in the usual sense of the word – it usually means more work as fresh subjects pour in from all sides and have to be tackled no matter how tired one is.

Anyway, there were the caterpillars refusing to be ignored, so we took them back in a paper bag, together with large supplies of wortleberry leaves. Back at the hotel this was replaced by a plastic box covered with cellophane, wet moss and Exmoor growth of small size. We left them with what we thought an adequate supply of food, but next morning my husband announced they were starving; they'd cleared the lot and looked quite languid. We remedied this situation quickly, but it was apparent that if we were to keep them through hibernation, chrysalis stage and beyond, which was my hope, it was going to be hard work.

Have *you* ever listened to a caterpillar munching? or watched its little mouth sawing systematically backwards and forwards across a leaf? Neither had I – quite an experience. In this case the caterpillars were those of the oak eggar moth. We took them out in the car with us most days and let them out periodically for runs, mostly to reassure ourselves they were all right.

Returning home, the food supply proved difficult; a substitute for whortleberries had to be found. I was giving them a run near our conservatory, turned my back for a second or two and when I looked back there was only one left! Frantically I searched and was rewarded. Two had made the mistake of going into the greenhouse and were spotted. One, whom I'd given up for lost had crawled up a strawberry plant some way off and I heard the plop when he missed his footing! This led me to offer them strawberry leaves and it worked.

I managed several little watercolours of them during this period (*fig. 113*) and, although we kept them going in the office-cum-spare-room for five months, a sudden cold spell carried one off and the remainder were overcome by a fungus which is apparently common with this particular

113 Mullein moth caterpillar and a young puss moth caterpillar. Pure watercolour notes these, and a fine brush. Such tiny things but such variety to be found!

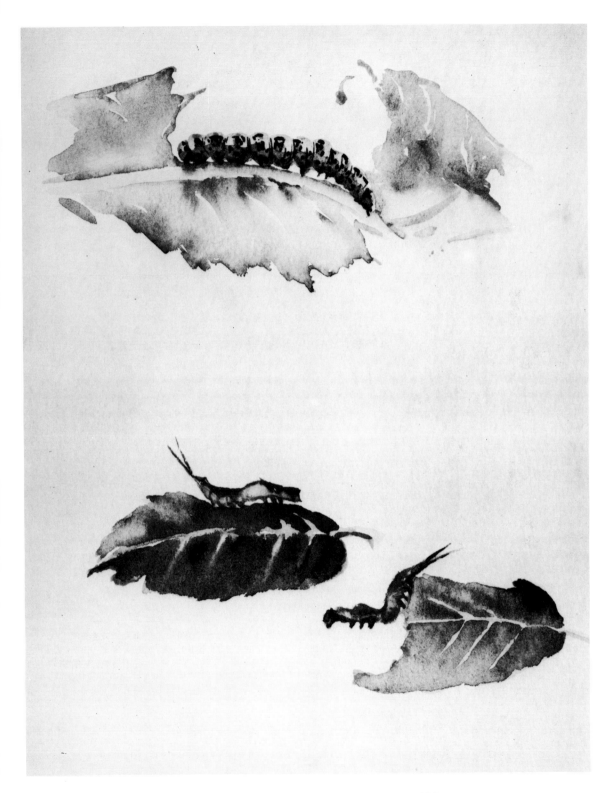

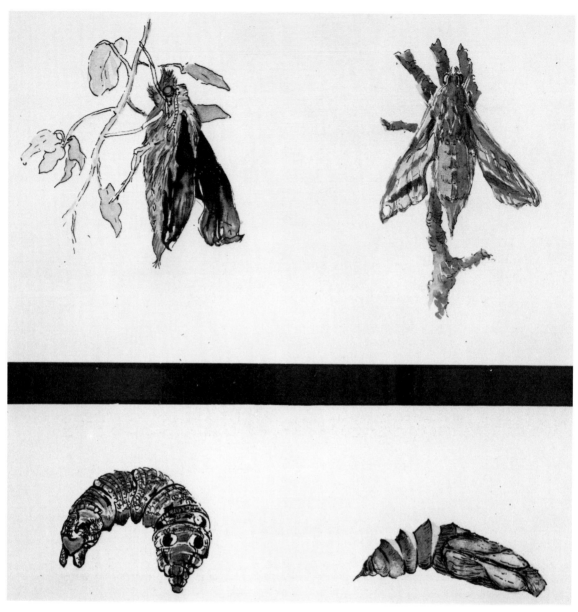

114 Pink elephant hawk moth. This was one of my successful efforts to 'carry a caterpillar through' its cycle into a beautiful moth. You will see that it is just drying out after emerging and so the wings are not properly open yet. It was an enjoyable exercise. Watercolour and a mapping pen used here.

115 (*opposite*) This was a very rewarding exercise. We managed to bring this handsome privet hawk moth right through the different stages of its existence and I did my best to get all the details in watercolour. A very splendid caterpillar this! I used a few touches of ink and a mapping pen in places, the rest was done with a fine brush.

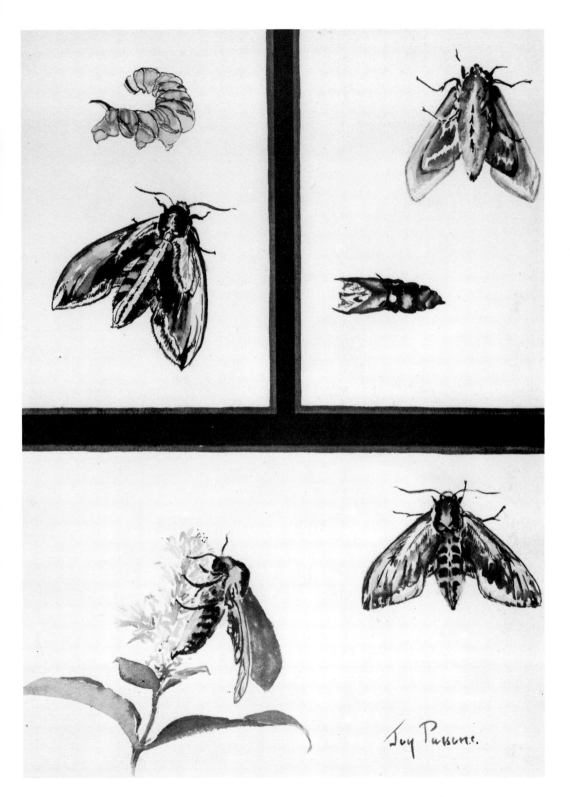

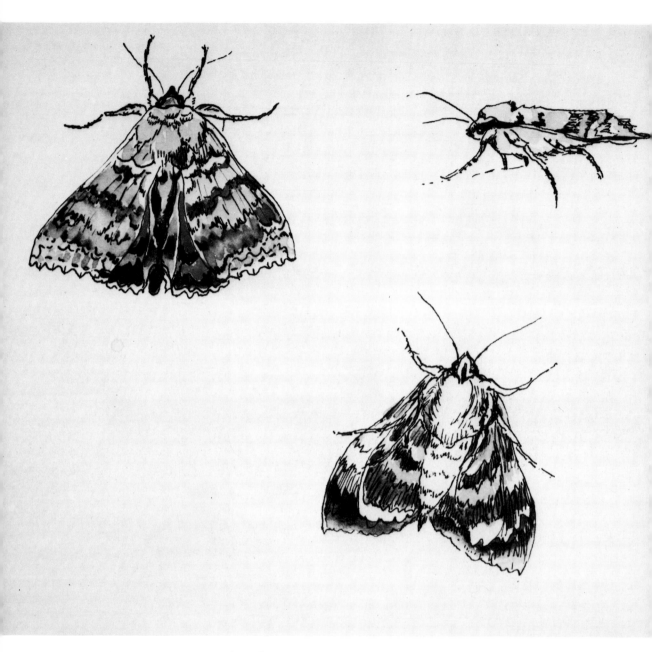

116 A close-up and as careful a study as I could manage of a red underwing moth. A little watercolour and a mapping pen were used.

variety. Since then, however, I have been more successful and have had the excitement of seeing an elephant hawk moth hatch out, pink and green and beautiful. I was able to add his portrait to the sheet on which he already featured in the caterpillar and chrysalis stage and which had been waiting all the winter to be completed. Fig. 115 shows the privet hawk moth. Next subject? As I say, one just never knows.

Paintbrush Versus Fishing Rod

Probably unlike most 'Fishing Widows', I was always thrilled when my husband got an invitation to a day on that queen of rivers – the Test; I would rush to the calendar to see if I was free to go too and this being settled, I was half-way there already in my mind. My father wielded a fly-rod from his earliest days and, destined to marry another fisherman, how could I escape from the lure of river or loch, great or small!

Our last trip is still quite vivid in my mind and is perhaps worth recording here. The pattern on these trips varied little, and when the special day arrived, the car was piled high with tackle and sketching kit and a certain amount of food. Even from a painter's point of view there is that something extra about the Test. Clear and glittering as cut glass it greeted us as, on that day, we unloaded and looked expectantly around us. Here, at least, times appear not to have changed and one is quickly at peace.

My own plans were laid and when the fisherman had set up the rod and made his first cast, now lost to the world, I blissfully set off up the rough track from the river to pick wild flowers for a watercolour panel. Back and forth I went, darting from side to side like one of the gorgeous dragonflies around me. A blossom here and a sprig there, but I must discipline myself; up one side and down the other – mustn't miss anything. Jewel weed sparkled across the fence and though highly tempted I didn't care to cross the boundary; I was a guest and it was in a neighbouring beat!

Returning eventually to the hut to put my flowers in water, I was immediately side-tracked. A couple of water voles under the nearby bridge caught my eye. Out along the decaying timbers I crawled on my tummy, complete with a sketchbook and miniature paintbox. Peering through a hole in the woodwork I made rough notes. Raising my eyes for a second I became aware of a weasel dashing across towards me and if three helicopters hadn't flown overhead at that identical moment, no doubt we should have exchanged surprised glances – at his level! The secretive movements of a moorhen caused me to peer through yet another gap, and below was an enchanting view of her nest and within it a mixture of eggs and youngsters. At no time could a young moorhen be described as 'pretty'; more like a wizened old man with a beard, but they are very hard to come by for recording purposes, so I drew fractically and managed a little colour also. I was acutely uncomfortable but one had to ignore that.

Upstream, fighting coot roused me from my labours and, rather exhausted, I returned to base for refreshments, liquid and otherwise! When joined by a hungry husband and notes were exchanged, it appeared that, so far, I was winning with regard to the 'catch'.

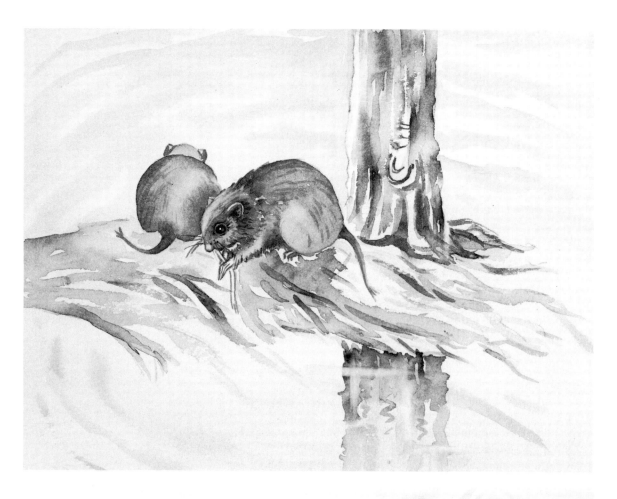

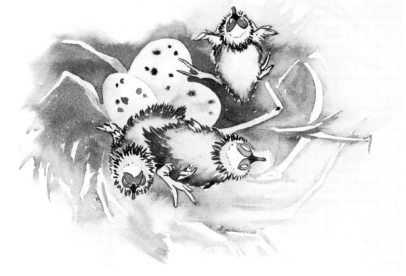

117–121 The River Test collection. (These first appeared in *The Countryman*.)

117 (*above*) Water voles. (Payne's Grey watercolour.)

118 (*right*) Moorhen's nest with eggs and chicks. (Payne's Grey watercolour.)

119 (*far right*) A coot. (Payne's Grey watercolour.)

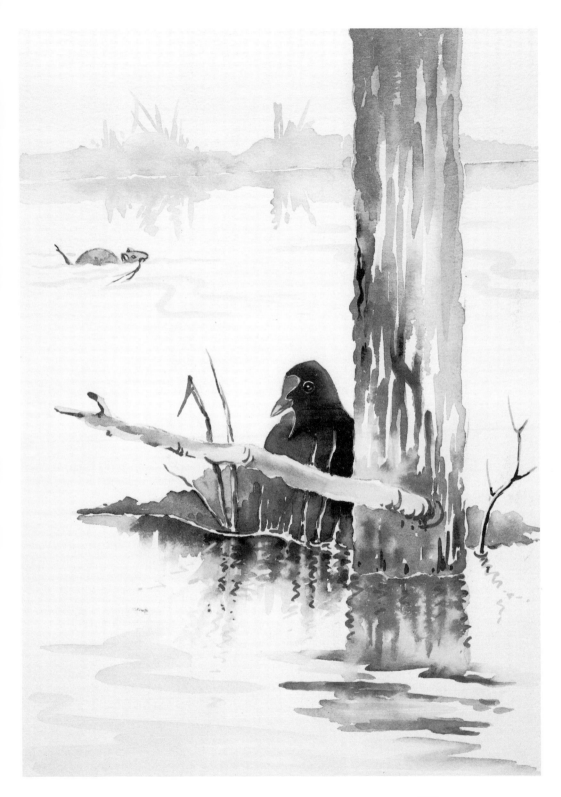

119

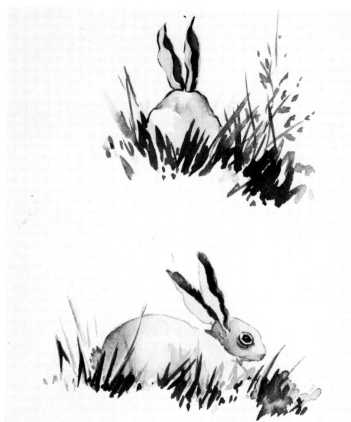

120 Skipper butterfly and damsel fly. (Felt tipped pen.)

121 A hare. (Payne's Grey watercolours.)

A short rest and both of us were off again. A skipper butterfly this time was the novelty for me and then, to my right, a swift movement in the long grass showed, on closer inspection, a pair of ears belonging to a good-sized hare – lucky me! More stalking took place and I managed to get an impression of two positions. A gathering thundercloud was now lighting up the trees and hut across the meadow in one of those rare and spectacular moments when the foliage is lighter in tone than the sky. Very beautiful, but I fled for cover.

Later the moorhen plucked up enough courage to return to her nest and I could just see her in semi-silhouette from the hut window. *More* drawing; I had worked almost non-stop since arrival. Time was running short. Soon it would be over, this glorious day. As dusk fell and I could hardly see, the evening rise started, and above and below the weir the elusive monsters started to 'plop'. For the fisherman the witching hour had arrived but whereas the previous trip had produced magnificent rainbow trout which had *first* to be painted and then eaten, today his catch had been below the limit and, therefore, returned to the water. I was sad for him; in earlier days many a fly had I cast myself, but I could never bring myself to kill them, and what was the use of that? So the paintbrush took over from the rod, giving me perhaps an unfair advantage – my 'catch' no longer being dependent on piscine temperament and my subject matter unconfined!

A Waiting Game

It's surprising the things that sometimes happen in our small, walled garden.

'I've got something for you,' my husband announced one day, uncovering a milk bottle. Inside was a beautiful little bank vole which had been enticed within by shortbread crumbs. Having had all his geranium roots eaten in the greenhouse in the previous cold spell, my husband was not taking any chances and had set a simple trap. Needless to say my 'recording hand' was twitching already! The bottle was rebaited and yielded up two more welcome models. Once again we sacrificed the dining room table and 'Sixpence', 'Tuppeny' and 'Teeny-wee' took up residence in their large and specially made glass house. The lid of their home was also transparent so that I could see them from all angles.

Fascinated, I spent hours watching and waiting to make notes. Quick and jerky in their movements they were like tiny marionettes; bright, beady eyes and, unlike mice, *no* unpleasant odour. In fact, they were incredibly clean and spent long sessions at their toilet and religiously used their self-appointed 'loo' well away from the nest. Catching a 'shot' of them actually washing their faces was a temper-wearing job. Their little hands flashed up and down so quickly that it was terribly difficult to catch the action correctly. It was, of course, the usual game of patience; watching and waiting with a pencil. Sometimes all I would get would be a hind leg here and a forepaw there; ears from behind, ears from in front and so on, but gradually I got used to the new shapes and got them in positions and engaged in antics that normally one would never see.

I loved my voles. Now I must have at least 80 drawings of them in different positions. 'Playtime' seemed to occur about 6 p.m. when we were having our evening sherry. They seemed to wake up then and a happy hour was spent by all! Two whiskey bottle tops made first class food containers and when we went out to the New Forest we always brought back something for them. Rose-hips were great favourites although apples were first preference; they also ate quantities of our museli. They hoarded overnight what they didn't consume and on 'cleaning days' we unearthed these treasures. Branches with various young shoots, moss and any greenstuff we thought they would fancy were imported and then we'd settle down (my pencil poised) to await the explorations which usually took place about 20 minutes after all was quiet. Many of my sketches were obtained during this period. New twigs and foliage gave them an opportunity for climbing and house-moving. They were very agile. Most of the time they burrowed underneath the surface, having long tunnels through the moss. In fig. 123

122 Two bank voles, a robin and a blackbird in just a few minutes as I sat quietly in the garden one afternoon.

123 Bank voles. This is a sheet of the sort of sketchbook notes which are needed to buid up a complete animal unless one is lucky enough to get it all in one sitting! As I mention in the text, we put a good thick layer of earth and peat into the bottom of the dry aquarium which made the temporary home for tea voles and you will see Tuppenny frantically excavating in this layer making a run for himself. I was lucky with this one and think I managed to get the twist of his body.

you will see Tupenny busily excavating; I was lucky to get this impression of him from outside the glass case. Lumps of old tree bark were bitten into shreds and sometimes the building operations threw up showers of the peat and sawdust mixture beneath the moss.

'Teeny-wee' was the last to be caught in the milk bottle and whether the fact that he was sitting in a puddle of rain before we found him had given him rheumatism or whether he was the 'runt' of the litter, I don't know, but his hindquarters were rather shrunken, and so he was easily recognisable.

By now I had built up a considerable reference library of drawings plus a couple of watercolour sketches; it is important to have both *colour* and *line* to refer to at perhaps a much later date when one's memory has become dimmed. Incidentally, don't forget, whatever your particular interest or subject matter may be, it is vital to keep some recording instrument handy at all times – pen, pencil, crayon, charcoal, etc. – it is always at the odd moments that the opportunities arise. Frequently I come across forgotten treasures on old envelopes, bills, and so on – perhaps a landscape note taken from a railway carriage window, perhaps a bird's wing or a beetle, jotted down and tucked away for future reference.

We had hoped for baby voles, but after six months it was obvious that they were not going to oblige, so we let them out into the great outdoors again. This whole period had been another challenge and a most enjoyable exercise. The fact that the shapes were different and that I was not used to them produced much of the enjoyment. The items most difficult to record were the voles' beautifully made little hands and feet and the fascinating way they held their food and ate in an almost human manner. The flowing lines and curves of their make-up gave an opportunity for drawing with ink and fine brush which is a preference of mine. Some are in monochrome, some in colour and some also give the simplicity of black on white and white on

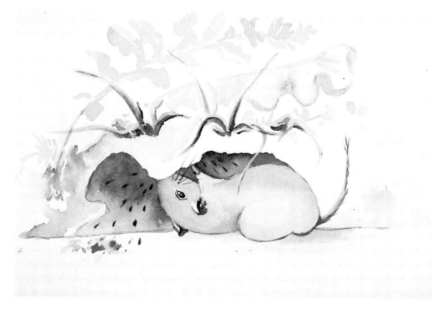

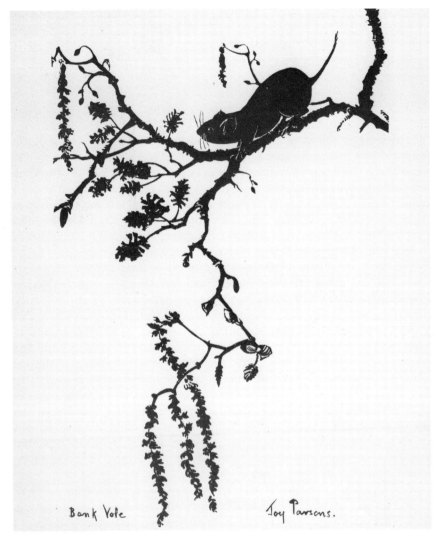

Bank Vole Joy Parsons.

124 Never minimise the impact of a little solid black. This is Indian Ink brushwork. Alder catkins are a delight to do either in ink or watercolour.

black. I had made notes such as feet pink, more hairy against the light – all for reference.

I also often made expeditions to the garden and would dress myself up for a chilly 'sit-in', usually with rewarding results. Just waiting – it is cold work and sometimes you draw a blank – one is acutely conscious of all the noises – rustling, tiny scampering feet, a blackbird peers over the fence; a wren twitters in disapproval and then perhaps a lightening-like movement will catch your eye and there is a vole – soundless as the falling dusk! I include a sketchbook note of an afternoon's vigil (*fig. 122*) – just what occurred whilst I sat there. The nicest position of them all, however, was caught on an October afternoon when the apples were lying on the ground, and I was just lucky (*colour plate 7*).

High-Rise Flat

The month was February and whilst breakfasting I heard it again and again, loud and very insistent: 'quack, quack, quack'. I recognised it instantly and translated it quickly as 'Where is my nest box, why isn't it ready?' The duck was standing on top of the bare 6-foot wall which separated my neighbour's house from our own and which runs down to the river. She was gazing up at the window. I opened it and leaned out. I must explain here that we live aloft over studio, garage, etc., and so have an excellent view of what is going on in the river. The duck was looking very aggrieved and quacked again.

'I'm sorry,' I explained, 'it looked very untidy up there all the winter so we took it down temporarily. I'll have it back tomorrow, I promise.' After giving me another piece of her mind she flew off. I hadn't seen her all the winter and so felt my lapse of memory was excusable.

The nest, an old apple box, was put up that morning, complete with earth, leaves and a landing stage at the entrance. Three days of wind and rain and no duck. The fourth day, however, I heard the familiar voice again. She was quickly in her box and going through the 'preliminaries' – the property was let.

After spending the necessary period going round and round and adjusting the furniture, she flew off and was again absent for another three days but this is quite usual. What she had not reckoned on was the fact that another and younger duck also had designs upon this particular box and installed herself immediately.

No. 1 duck arrived back all ready to take up residence and confrontation in no small way took place. No. 1 laid her egg daily and as soon as she left the nest, No. 2 duck crept in like a thief in the night and did likewise. The result? 24 eggs and worried landlords! At this stage we put up another box further along the wall and removed 12 of the eggs. The outcome of this was that No. 2 would, after long staring matches with No. 1, go reluctantly into the second box and we thought all would be well. Not at all. As soon as No. 1 took off, No. 2 moved across and laid again.

After a whole week of this bill-to-bill argument, which I was lucky enough to witness from our window and of which I managed a quick drawing (*fig. 125*), the younger duck gave in and the original owner settled down to the job in hand – it's her third year. In due course the family hatched. With a little help from my husband she got them down and off successfully, which was no easy feat. She was a wonderful mother and the whole ten survived and flourished under her rather sergeant-majorish care.

She had only been gone a week when No. 2 duck reappeared and started all over again! The eggs all hatched, but the young and inexperienced

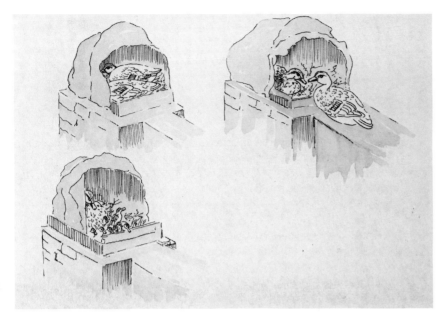

125 Three somewhat crude impressions of the 'High-Rise Flat' sequence!

126 This was a hastily pencilled sketch of the tenant of the nesting box and her brood as they sit on the edge of our little river frontage.

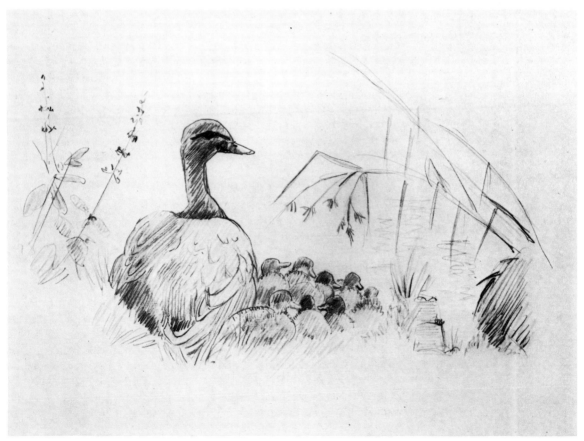

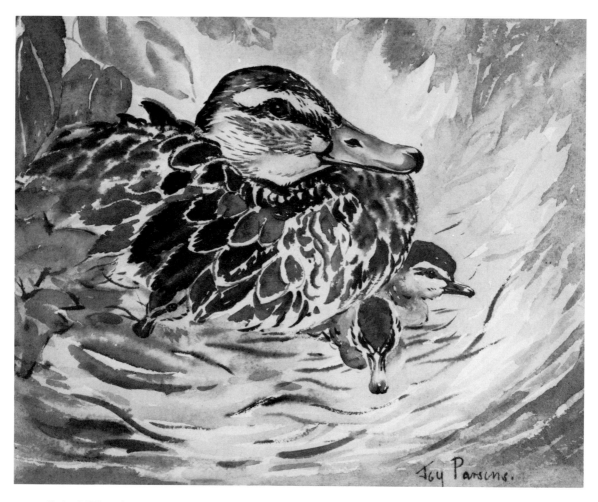

127 (*below*) There's
nothing quite so
appealing as a baby
mallard duckling.

128 (*above*) This was one of my earlier broods and the hen was so tame
that she sat happily as a model so it was painted on the spot. I can't
remember whether I drew her in with a fine brush and blue paint (as is my
wont) or gave pencil indications. She had her nest under our laurel tree in
the small riverside garden. Once again, pure watercolour.

mother was no match for the predators and hazards and all but two were
carried off. The drake remained in attendance, which is not always the case –
nine times out of ten they're 'off with the girls', leaving Mum to do the
upbringing. But this remained a happy foursome who were up for food every
day.

But, believe it or not, that August we had yet another tenant who sat
happily in the apple box whilst I put a cover of laurel leaves over the top to
keep the intense heat off her. She was so tame and trusting that I got up on
the steps and did several drawings at close range. Not easy, but certainly
worth the try. What *is* the attraction of this special box, six feet up and in the
heart of the town? Perhaps they just know I love them!

126

A Pondful of Paintings

Beauty, so they say, is in the eye of the beholder; in no case is this more true than with regard to the artist. One person may enjoy painting dustbins, someone else boats whilst, I, very definitely, wanted to portray frogs, toads and newts during this particular period. The dictionary describes beauty as a pleasing combination of qualities and, in my opinion, these little creatures supply this combination. I had to observe and record the life cycle of a common frog and common toad. So, on a lovely April morning I set off for the Forest complete with jars and a net, feeling, I must admit, slightly self-conscious. After wandering and searching for a while, a lovely brackish pool yielded up the necessary frogspawn and, something much rarer in these days, I've since discovered – long, exciting ropes of toadspawn. Triumphant, I was just setting off with my spoils when I happened to look down and saw two gorgeous palmate newts nearby, just asking to be painted – a lucky day indeed. Home I went, full of plans.

A week later Cis, my once-a-week and much valued helper, gave me a long-suffering look. 'I've been robbed', she complained, 'there's not a bucket or bowl left in the house.' It was true: my spawn had been split and split again, and the tadpoles were hatching on the window-sill, under the television and on the balcony, in every available vessel.

I worked very hard. As I mentioned before, not being primarily a naturalist, my work is done purely by observation and the use of a magnifying glass. It took me six months to get all the early stages and I constantly made drawings. As with all wildlife it is a waiting game and requires much patience; one or two strokes sometimes, and the little creature would be off. I'd start another study on the same sheet and then maybe he'd go back to his original position and more lines could be added to my first effort. As I progressed I became more conscious of the bits of extra information that might be needed at a later date – how many toes on the fore or hind limbs, for instance, in the case of the now maturing frogs and toads, or the exact markings on the tadpole tails. I had added four other specimens from Exmoor to my collection and was surprised at the difference in size and markings. Even a tadpole can give you a very searching glance through a magnifying glass, as you'll see (*fig. 130*) – I'm sure they must have thought my eye belonged to a horrible pike.

This job was to be what I'd term a documentary or recording piece of work and was a very good exercise. This meant that if I used line and wash it was to state facts and not used as loosely as if I was engaged on a landscape.

In the first instance I was impressed by the spawn floating in the aquarium with the light behind it and waving amongst the weeds as shown in fig. 129.

129 (*above*) Lovely ropes of toadspawn, so hard to come by these days. You can see the stages of development here; some of the little tadpoles have actually hatched out; they cling onto the nearby greenery for a while.

130 (*opposite*) These little chaps are greatly enlarged so that you can see their expressions! They were actually in the aquarium nibbling a piece of Sunday's left-over chicken – it went down very well. Obviously I used my magnifying glass a lot here.

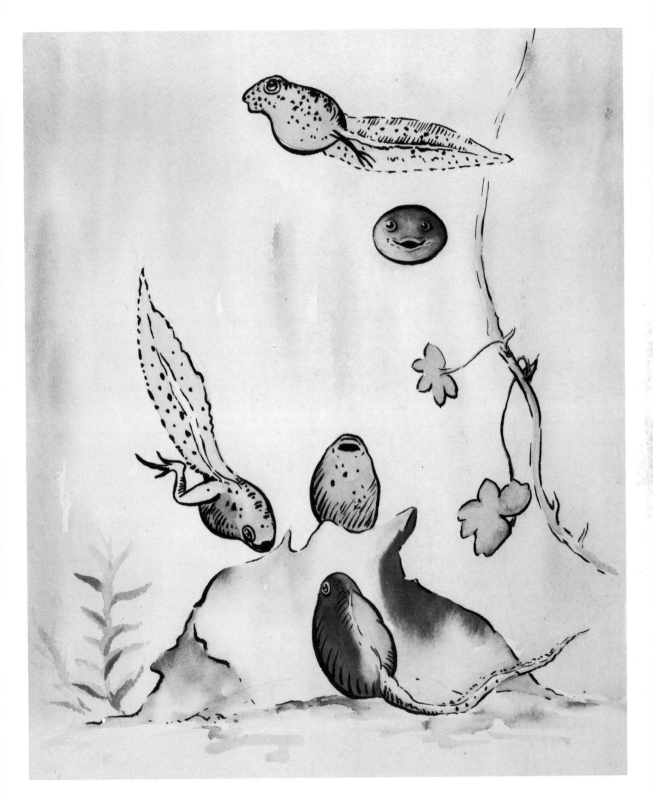

131 It is surprising how tiny and yet perfect these little toads were – Nicholas and Nancy in infancy! Also another little frog scaling up the inside of a jam jar. All mapping pen and Indian Ink sketches.

It was colourful and exciting, and I did this in pure watercolour, straight in with the brush, lifting off colour here and there. (You will notice that one or two of the eggs are just hatching and changing shape.) The next stage I found equally decorative – the little black objects just hanging on to the weeds as they do for a while before becoming active tadpoles. I really made two separate studies of these stages but have put them both together in one illustration – fig. 129 (toadspawn in this case).

Keeping my models fed at this later stage was a problem. However, expert literature said: 'when they get their legs, give them protein.' Racking my brains I suddenly remembered our Sunday lunch remains and tried it out. It worked very well and fig. 130 shows what must be the first ever portrait of three 'Parsons tadpoles' tucking into cold chicken! Only a little at a time or it made the water nasty. This appears more as a form of line and wash but the line was done with a very fine brush; nine times out of ten, I prefer it to a pen as it gives me soft, flexible lines instead of hard, unvarying ones – it is a matter of taste. At times I used a mapping pen direct but it is rather fine for reproduction purposes.

When I had reached the little frog and toad stage the work became difficult as once they had lost their tails they quickly became amazingly agile. Such enchanting positions they took up on the water weeds – I was fascinated. You can see for yourselves. The toads, in particular, were unbelievably tiny at the beginning. I decided to keep two from my collection as pets (Nicholas and Nancy) and they were still housed in the now dry aquarium on our office windowsill. It was tastefully arranged with weeds and stones and had a butterdish pond. Greenfly were their main diet but in the autumn it grew difficult. My husband, resourceful and country-bred, got over this problem by placing an anglepoise lamp above their home with a specially prepared lampshade – wide at the top and narrow at the bottom, with a hole in it. In the evenings the window was opened, the light switched on and Nancy and

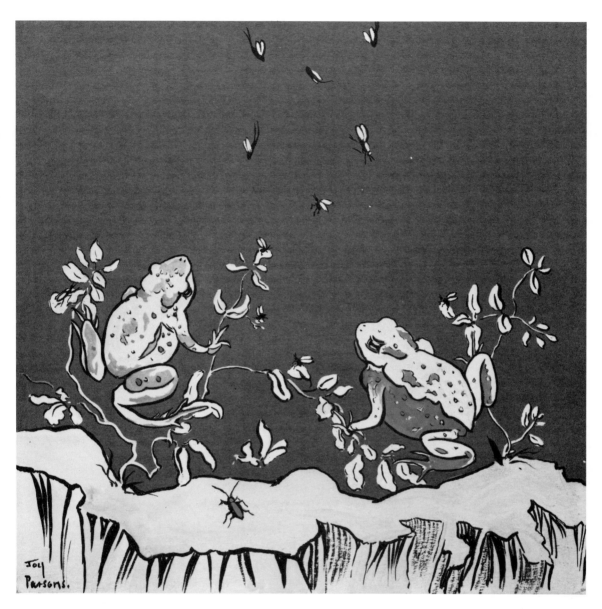

132 Nicholas and Nancy, waiting for their food to fall like Manna from Heaven.

133 Nothing should be too small for our notice. This snail supplied me with several drawing problems.

131

Nicholas could be seen sitting on their stone below waiting for their food to fall like Manna from Heaven. Attracted by the light, the mosquitoes and small flies came in and then fell helplessly down through the paper tube into the waiting mouths below. The more one studies any form of wildlife the more shocked one becomes by the way everything eats everything else! Only last week I arose one morning just too late to stop a snail from eating a very baby newt. Incidentally 'Snail's pace' doesn't make sense to me – they seem to get around at a considerable speed when they want to and were interesting to draw, both in silhouette and otherwise.

Another thing that astonished me was the enormous amount of life that is contained within a small drop of pond water! From the handful of weeds and bits that I had grabbed up in a hurry from the pond, all sorts of life developed. I found cadis flies, water spiders, and then one day a lovely red damsel fly climbed up a stem to the surface and shed its nymphal skin on a leaf. All interesting, all paintable and a new challenge; so often we never really *look* sufficiently at things to realise their potential.

Whilst drawing I kept on checking from one point to another: the distance, for instance, between the point where a newt's tail joins on and where its hind limb leaves the body; where the different markings appear down a frog's back, and so on. Check and cross-check again – one must keep doing this.

There came a time when I was brought to a full stop in my studies. Frogs and toads take several years to mature and so I had much fruitless searching before I found the right sized models to complete the picture. I was beginning to give up and then I had occasion to spend a night in a nursing home near Birmingham – far from home. About an hour before I was being picked up by a friend for the return journey, I made the wonderful discovery that this house had a magnificent cellar and, believe it or not, a wonderful variety of frogs and toads! So down we went, the gardener and I, and we returned home with a handsome frog, a nice podgy toad (Timothy) and an in-between frog. They travelled on my knee in a cornflake box and survived the journey well.

It wasn't, of course, easy to get close enough to my models for long periods of inspection. However, in our greenhouse I managed to get Freddie the frog into my household mixing bowl and enveloped myself and the bowl under an old lace curtain thus getting him for a close-up! This time I drew him with a small brush and ink, putting in all the detail I could see, and later did another from it in gouache, using tinted paper of course. He caught me unawares once and, making a mighty leap, escaped on to the windowsill but kept the pose just long enough for me to get the essentials, as you will see (*fig. 136*).

My toad was an easier proposition as he appeared rather to enjoy the greenhouse and we used to gaze at each other for hours whilst I drew and painted him and searched out his knobbles and curves. He had the most beautiful orange eyes. Like humans, each toad is individual; at a later date I was given another one who had a passion for climbing up the sides of the fuchsia or geranium pots and taking possession of them.

134 These were all mapping pen jobs. Three stages in the development of a tadpole to frog, the last sitting on a water crowfoot leaf.

135 (*opposite*) Young frogs make enchanting models, like the newts, they take up such *elegant* positions.

132

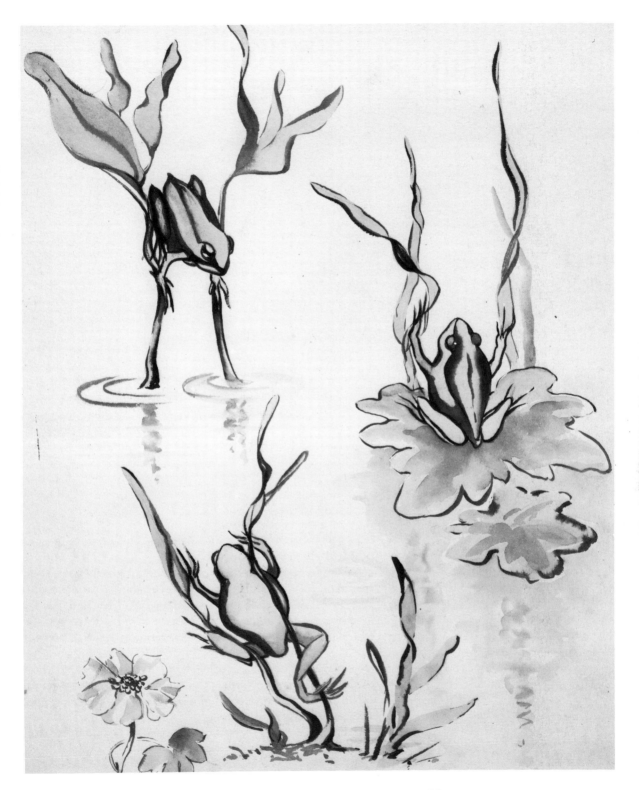

133

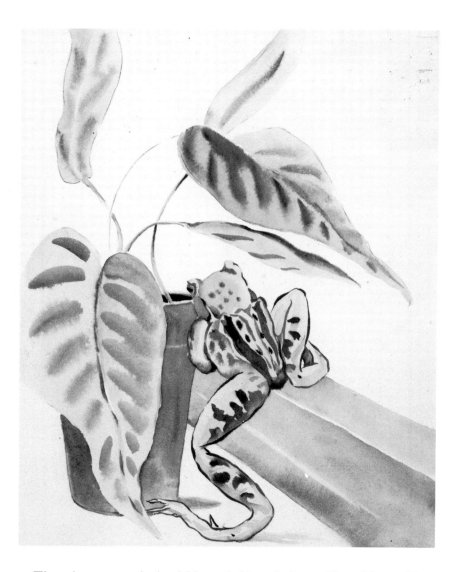

136 An action picture – the frog making a mighty jump out of the pudding basin on to the windowsill. There he stayed poised, one foot on the sill, so I was able to get this 'shot'. Watercolour and Payne's Grey, strengthened with a few strong brush strokes.

The palmate newts had quickly settled into their new life and I was able to include my special pet, Salome, busily laying her eggs on the waterweeds – you will see that she carefully turned over the edges of the leaves afterwards (*fig. 138*). The afternoon I found was the best time to study them, as they were sleepy in the sunshine and twined themselves around the weed in order to take their siesta. Sometimes I'd just use biro, which was quite good, or perhaps my No. 6 brush and a watercolour straight in. My collection of poses and creatures became considerable; the idea was to be able to produce the entire life history upon one sheet if necessary. Then my original drawings could be traced off and arranged tastefully. In the case of the palmate newts, I commenced very often with the eye and then worked outwards.

Another pool at a later date revealed the warty or crested newts which are

134

larger and slightly slower in their movements than the palmates; they are even more paintable as they have wonderful psychedelic orange tummies with strong black markings. The female had a blind eye and frequently lost her food on account of this. It appeared to be a cataract. I often wish I could shed my skin in the way these little creatures do. Sometimes one can see them rubbing it off bit by bit against the water weeds. I once managed a painting of a discarded skin lying across the stem of some water crowfoot; a thin, silky film showing even the tiny fingers intact. I drew the outline quickly in pencil at the time and found it an exciting revelation – *such* a change from landscape! Beside my first 'shots' I made many notes such as: black pupil, gold iris and then dark rim; underside of tail is yellow in females; yellow palm and fingertips; female has indent down back instead of crest, and so on. All these things I knew I should need if I came to translate

137 I did my best to portray all the bumps and nobbles with which a toad is blessed – as I say, she was a very good model.

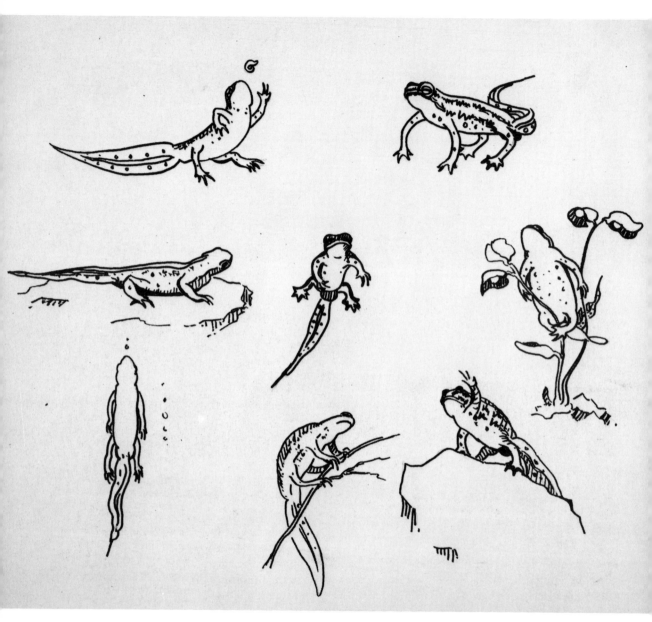

138 This is rather a special sheet – you will realise the amount of time and patience consumed here! I had made many, many little sketches of all the 'goings on' in the new aquarium and finally decided to put them all on one sheet. It was done on cartridge paper with a felt-tipped pen. It includes Salome, my particular pet; you see her here sitting out on her stone watching (apparently) the television! Below her another is rising to the top of the water with his arms close to his side and to the right of Salome you will see him floating gently down again, arms and legs spread out, having taken air. On the extreme right is Salome laying her eggs on the undersides of the leaves – wasn't I lucky to get this close-up!

136

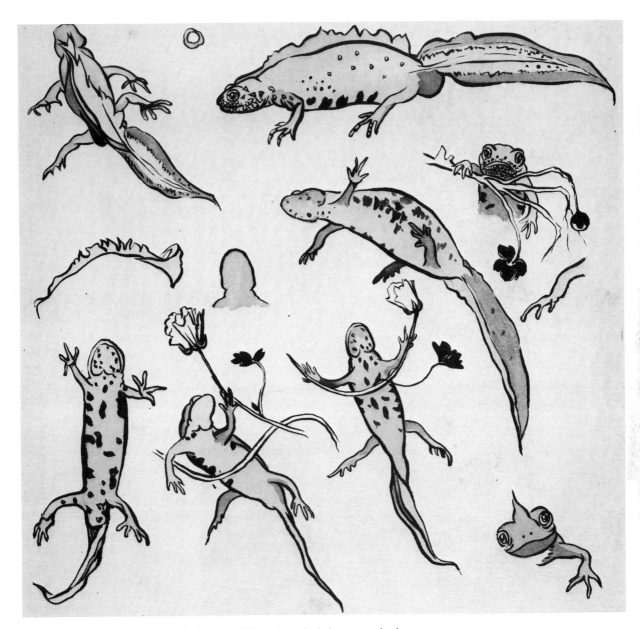

139 Now we're well and truly into my 'Newt' period; here are the large crested or warty newts and very handsome they are too. For some reason they did not stay as residents in our pond as did the palmate newts. Payne's Grey watercolour and as much detail as I could with a fine brush. See the crest running down the back of the fine chap at the top of the sheet.

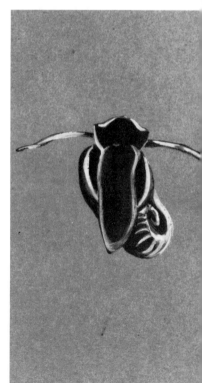

138

my drawings into colour. Incidentally, most of these illustrations have been converted back from full colour into monochrome for reproduction purposes – Payne's Grey to be exact.

It all comes back to two things: observation and that old-fashioned thing called drawing practice. Make no mistake, I dearly love to float colour on in the widest and broadest sense – so often I paint in direct in watercolour with no pencil and I'm very attached to pastel, mixed media and abstractions from nature and all the off-shoots – but it is only common sense that, in order to express oneself and one's vision in a reasonable manner, we must be able to put our lines where we want them to go. By the way, don't be tempted into *starting off* on this particular branch by using a colour transparency or similar reference first – these should only be used to 'check up' if necessary, when you have used your own eyes, power of observation and ability to their fullest extent. Otherwise your personal vision and creative faculties will remain negative and you will learn little about wildlife.

Don't forget that little frogs can drown quickly if they do not have access to dry land when they cease to be tadpoles! On the other hand, I have seen them scale up a piece of perpendicular glass behind which I thought they would be safe! Lastly, you might like to know the fate of Salome newt. She eventually fell ill and I was forced to take her to the vet. After a solemn examination (we poured her out on to a saucer in the surgery) he diagnosed a complaint that is also common to sheep and comes from a certain river plant. No known cure was available, so I took advantage of his 'I don't suppose you'd like to put her down yourself, would you?' and sadly left the jar behind and went away with a sense of considerable loss. My depression was slightly alleviated, however, by the loud grumblings of the hefty, grimy workman in the waiting room who was explaining to all and sundry that it was no good going home for his tea until he could hand his wife the antibiotics for the poodle. The point is that if you follow your paintbrush, you never know where it will take you.

140 (*opposite*) This was an interesting little group, especially the shed skin of the newt; I couldn't think what it was first of all until I learned of their habits. The greater ram's horn snail was crawling up the side of the aquarium facing me and the fat cross spider was quite an exercise. Gouache paint has been used for all these, on tinted grey paper.

141 Two extreme close-ups of a frog and a newt. (Mapping pen and fine brush used.)

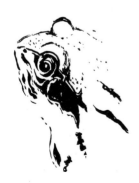

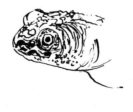

Conclusion

Here we are – the end of the book. What have we achieved? As far as I'm concerned I would hope that perhaps I've inspired you to try your hand at these birds and little creatures that form a part of our life, when we stop to look!

Also, as we cannot write until we have learnt to spell, I would hope that perhaps your knowledge of the different media has been extended. As a splendid tutor of mine once said to me: 'Don't forget, all the trains go to Clapham Junction and after that they branch off.' So it is with you. After you have acquired a certain knowledge of how the media work, your own personality will, or should, take you on your own special journey, and remember the more you learn, the more ignorant you will feel!

Studies, studies; sketchbook handy at all times. Training oneself to observe, search out and record and also to be prepared to exaggerate and exploit what attracts one in a subject and constantly to ask oneself the following, and similar, questions:

How does an eye relate to the beak?
How far away it is?
How high up in the head does it come?
How long is the beak?
How does the bit of landscape you might use for a background relate to the
 natural habitat of the bird?
Have you got the plumage right?
Where on the hedgehog's body do the spikes change direction?
Do you remember to half-close your eyes sometimes to eliminate unwanted
 detail and to ascertain tone values?
Has your painting gone according to plan or have you been led away from
 the original idea and focal point?
Do you realise the importance of sketchbook 'notes' and drawings?
When using watercolour do you remember to put plenty of water with it?
How much have you used your eyes this week – have you managed to register
 what you've looked at, whether it was bird, beast or flower?

Don't forget what has been called the 'mechanics' of the situation; the common sense angle, i.e. have your water pot *handy* and your palette in your left hand; keep your board at a proper angle – it is no uncommon sight to see somebody with the board tipping away from them, fighting to make the wash run uphill! If you have no easel, put a handbag or folded coat on your knees, fat end outwards, and rest the board on that – always keep it at an angle.

At this stage I would like you to realise that this is not necessarily a book on 'how you must do it', but rather, a book on 'how it has worked for me'. So I wish you Happy Painting, and would like, in conclusion, to quote this lesser-known poem by Rudyard Kipling, reproduced by permission of the National Trust and Macmillan London Ltd..

When Earth's Last Picture is Painted

When earth's last picture is painted and the tubes are
 twisted and dried,
When the oldest colours have faded, and the youngest critic
 has died,
We shall rest, and, faith we shall need it – lie down for an
 aeon or two
Till the Master of All Good Workmen shall put us to work
 anew.

And those that were good shall be happy: they shall sit in a
 golden chair;
They shall splash at a ten-league canvas with brushes of
comets' hair.
They shall have real saints to draw from – Magdalene, Peter
 and Paul;
They shall work for an age at a sitting and never be tired at
 all.

And only the Master shall praise us, and only the Master
 shall blame.
And no one shall work for money, and no one shall work for
 fame.
But each for the joy of the working, and each, in his separate
 star,
Shall draw the thing as he sees It for the God of Things as
 They are!

Index